D0404706

ICONS

Tattoos

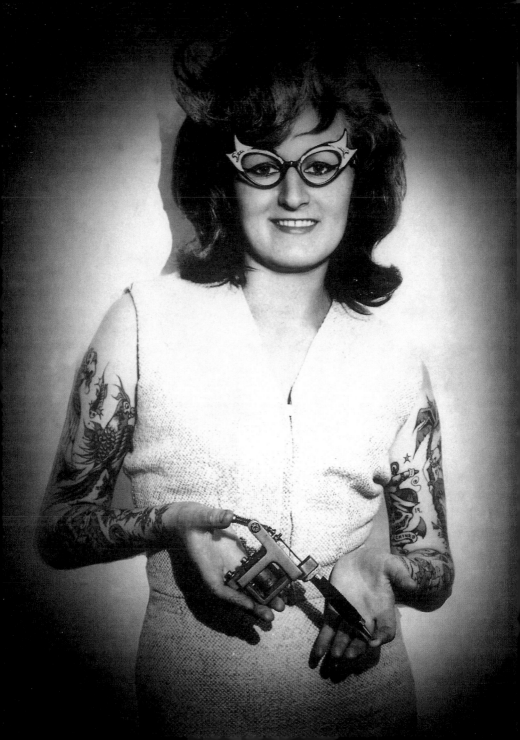

Tattoos

Henk Schiffmacher
Burkhard Riemschneider

TASCHEN

KÖLN LONDON MADRID NEW YORK PARIS TOKYO

Cover / Umschlag / Couverture:
Tattoo design by Henk Schiffmacher, Amsterdam, 1996

Page 2 / Seite 2 / Page 2:
Cindy Ray in her Studio, Ivanhoe, Australia, 1960s

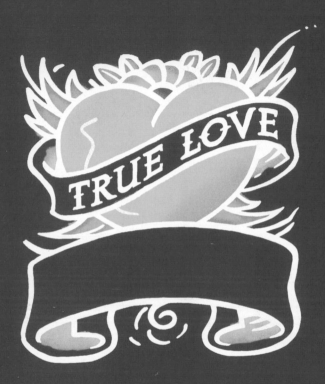

© 2001 TASCHEN GmbH
Hohenzollernring 53, D-50672 Köln
www.taschen.com

© 2001 for the illustrations by the Tattoo
Museum Amsterdam, Amsterdam
Text by Henk Schiffmacher, Amsterdam
Editorial coordination by Nina Schmidt, Cologne
Cover design by Angelika Taschen, Cologne
English translation by Deborah ffoulkes, Cologne
German translation by Marinus Pütz, Amsterdam
French translation by Jean Bertrand, Paris

Printed in Italy
ISBN 3-8228-5528-6

The publishers would like to thank Henk Schiffmacher,
Morrison, Texas and Jacqueline Schiffmacher as well as
Annemarie Beers, without whose help and support this
book would not have been possible.

In addition the publishers would also like to thank the
tattoo artists whose works are presented in this book.

Special thanks are due to all photographers and models
not mentioned by name, who have made this book
what it is.

Contents

Inhalt

Sommaire

On the History and Practice of Tattooing

As an art form, the tattoo is as ephemeral as life itself. It disappears along with the person who bears it. Cave paintings, sculptures, and architectural works all have a longer life span and transmit the culture of civilizations that have vanished.

A tattoo always raises questions that do not so much concern the technique but rather the meaning and purpose of the tattoo. The latter is the most important aspect of the subject which is usually incorrectly described or not all. Even important ethnographic works on the history of the tattoos of primitive peoples living in distant corners of the globe only describe certain aspects of the world of the tattoo. And yet, as Darwin observed: "There is no nation on earth that does not know this phenomenon."

The technique for bringing the pigments under the skin has not changed greatly the course of history. There are, however, great variations in quality because of the ease in using tattooing instruments and because of aesthetic considerations: the tattoo should be finely drawn, with lines that are thin, black and even. And then there is the craftsmanship: the application of the correct amount of pigment; correct penetration at the proper depth, without leaving scars. Even primitive cultures have developed astonishing tattooing techniques; for example, the Inuit: stitch tattoos into the skin with a needle and coloured thread.

In other techniques, the skin is divided up into areas by a series of preliminary cuts. These areas are then filled with figures. Another, less precise technique involves drawing lines and curves with a sharp stone to form complex tattoos with long rows of dots, spirals or other forms, as found in ancient Europe and among modern North

American Indians. In Indochina, people use the so-called chisel or comb technique: a row of needles, or sharp pieces of ivory or bone are fastened to the end of a stick to form a rake. The artist holds the chisel with one hand and hammers quickly with a type of mallet held in the other.

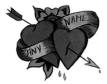

The Japanese method is a sophisticated manual technique using a row of sticks with needles joined to create a particular pattern. Details require no more than three needles; thick and thin lines and coloured or black areas call for larger numbers.

The electric tattooing machine, first patented by Samuel O'Reilly in 1891, is now very popular. In addition to hammering devices, there are also rotational machines, often used by amateurs or in prison, where a cassette recorder or electric razor can serve as a motor with results at times astonishingly good.

So much for the how – but what about the why? Tattoos can mark victory or defeat, can express joy or sorrow, or can be part of a ceremony or ritual accompanied by mantras, song and dance. Alternatively, a tattoo may express pleasure, sadism, torture or superstition.

One type of tattoo functioning as camouflage during the hunt may have developed from body painting. Tattoos may depict hunting trophies or a successful hunt or may seek to placate the prey, asking its forgiveness or even its approval. Cannibalism and headhunting also appear in tattooed images.

Another type of tattoo is performed on religious grounds: people want to ensure a place in heaven and tell God and the world about their devotion by means of the tattoos. In India and Tibet, tattoos provide assistance in getting through difficult periods in life. The attempt to drown out mental suffering by means of physical pain even leads to mutilation, burn wounds and amputations. People commemorate the deceased in this way or honour them by means of a tattooed "in memoriam". In the western world "memento mori" and "in memoriam" tattoos are also common. Possibly the best-known type of tattoo is that belonging to an initiation rite, as found throughout the world. It indicates the start of or transition to another phase of life, from boy to man, girl to woman, woman to mother or numerous other religious, social or other changes.

Tattoos can serve as a type of vaccination or other medicinal treatment. The Berbers and Samoans, for example, tattoo against rheumatism. Medical tattoos against eye diseases, headaches and the like can be found from Egypt to South Africa. The Inuit and North American Indians covered the skin with signs to protect against disease. The artistic welt "tattoos" of young Nubian girls in the Sudan and also common in other African states

function as decoration and vaccination: small wounds strengthen the immune system.

Tattoos can help to acquire certain characteristics by celebrating and honouring these very qualities in ancestors and spirits. In this context, tattoos consist primarily of those elements of the national or tribal history which are also of benefit to the bearers. Tattoos function as non-verbal communication. The lines on the faces of the Inuit telling the tale of a murder are also to be found among the Mentawai people. Tattooed spirals and lines on Maori faces narrate the story of the bearers' lives, genealogy and characteristics.

A more simple reason for a tattoo is the desire to induce a state of fear and terror in the enemy. In physical conflict the tattoo distracts opponents, reducing their concentration for a split second – a weakness which can be exploited. This is a principle behind the tattoos of the inhabitants of the Marquesas Islands: large staring eyes on the inside of the arm are intended to put off the opponent for that fraction of a second when the arm is raised to strike. Japanese gangsters, so-called *yakuzas*, take off their kimonos in order to impress their opponent with their body tattoos during the ill-famed and illegal card game, *hanafuda*. Mike Tyson is deliberately provocative with his tattoo of the deceased, omniscient chairman Mao Zedong, the father of all Chinese. Mickey Rourke achieves the same effect with his IRA tattoo. In the notorious Russian gulags, texts were often tattooed from shoulder to shoulder, declaiming: "A Russia without Reds" or "I thank the communist masters for my happy childhood", illustrated with a child behind a barbed wire fence. Abdominal tattoos were also common, showing Lenin and Stalin copulating with pigs. A tattoo can thus become the most extreme form of protest. It gives people the strength to survive, the ability to assert themselves in the face of daily humiliation. It expresses the freedom of the spirit in the prison of the body.

Another aspect is the tattoo as erotic ornament, making the body more interesting sexually, and demanding a response. Leather freaks, sadomasochists, rubber and piercing fetishists, masters and slaves often combine text and image in a tattoo to inform a possible interested party about the sexual preferences of their bearer.

Other tattoos are personal statements concerning love and friendship, patriotism, or against conformism, such as "Made in England" or "Made in Germany" for the nationalist skinhead; "Mother", "Mom" and "Mamma" as proof of family love. Anarchist and anti-establishment feelings expressed in symbols meant to shock the majority are frequently associated with murder, war, discrimination, drug use and perversion. One of the most famous symbols consists of three dots on the hand between the thumb and index finger, and means "Mort aux vaches", roughly translated as "Kill the pigs" or "Fuck the world".

Tattoos also mark important dates and events. Pilgrims record reaching their goal; sailors decorate themselves with "their" port, commemorate crossing the Equator, or rounding Cape Horn or the Cape of Good Hope. Soldiers bear their victories and battles on their skin, as with Vietnam veterans.

Tattoos also indicate group membership, seen in the totems of primitive tribes, the welts of the Yoruba in Nigeria, or the tattoos of the Hell's Angels, urban street gangs, or Chinese triads.

The advertising branch also uses tattoos, but simply paints the brand name or logo on the skin and photographs it, or engages someone who already has the tattoo they want. This practice is common, especially if it concerns a popular article. A favourite is, of course, the Harley Davidson, followed by Jack Daniels, Gauloises, Lucky Strike, Chanel or the Lacoste crocodile.

Tattoos recording medical information are still found in the American and English military. I myself once suggested that organ donors should be tattooed with invisible ink on an agreed part so that a doctor could recognise the tattoo immediately using ultraviolet light. The compulsory tattoo as a form of punishment – the branding of slaves, thieves, rapists and the like – is hardly ever used today. A gruesome exception was the Holocaust. Because tattoos were against Judaic law, the tattooed numbers contributed to the dehumanisation of the concentration camp inmates.

Tattooing is also performed on cosmetic grounds – birthmarks are removed, scars are covered or dyed in the appropriate skin colour.

In the West, tattoos are mainly associated with the lower social class – criminals, sailors, whores, soldiers, adventurers, perverts and the like –

and at the other end of the scale with the eccentrics of high society, the rich and aristocratic, intellectuals, artists and all those who make life more colourful. Around the turn of the last century it was the elite which had tattoos – every dynasty, from the tsar and tsarina to American high society. Today's elite is no different: film stars, the kings and queens of rock 'n' roll and many artists have tattoos, thus becoming cultural vehicles. Through their image and their behaviour they influence the life, art, fashion, morals, democracy, emancipation, and thinking of whole societies: people such as Sean Connery, Dennis Hopper, Whoopi Goldberg, Johnny Depp, Drew Barrymore, Julia Roberts, David Bowie, the Red Hot Chili Peppers, Nirvana, and the Smashing Pumpkins all have tattoos.

The nature and quality of tattoos depend on a society's level of cultural and economic development. A rich spiritual and mythical imagination is called for if artistic and cultural forms are to possess any diversity. Many tribal peoples otherwise dependent on oral tradition can follow their history back for a hundred generations by reading tattoos. As settlement, agriculture and hierarchical structures evolved, so too did primitive forms of art. People throughout the ages practised the art of the tattoo, and do so to this day, because their lives are a complex fabric of hierarchy, religion, respect and heroism. The entire art of the Pacific derives from peoples versed in the art of tattooing, perfected by the Maori of New Zealand. They are proof that tattoos are an indicator of a highly developed society and culture.

Henk Schiffmacher

Geschichte und Technik der Tätowierung

 Tätowierungen sind ebenso vergänglich wie das menschliche Leben. Höhlenmalerei, Bildhauerei und Architektur hingegen überliefern die Kultur ganzer untergegangener Völker. Tätowierungen werfen immer Fragen nach Bedeutung, Sinn und Zweck auf und werden als Kunstform meist falsch beschrieben. Zwar gibt es bedeutende ethnografische Werke über die Geschichte der Tätowierung bei Urvölkern, doch wird das Phänomen in seiner Gesamtheit kaum erfasst. Schon Darwin wusste: »Es gibt auf der Erde kein Volk, das dieses Phänomen nicht kennt.«

Die Technik, mit der die Pigmente unter die Haut gebracht werden, hat im Lauf der Geschichte keine grundlegenden Veränderungen erfahren. Wohl aber gibt es große Qualitätsunterschiede hinsichtlich der Technik und Ästhetik. Die Zeichnung muss fein und gleichmäßig sein, handwerklich geht es um präzises Einstechen und das richtige Einbringen der Farbstoffe, ohne dass Narben zurückbleiben. So genannte primitive Kulturen haben erstaunliche Techniken entwickelt. Bei den Inuits beispielsweise wird mit einer Nadel ein eingefärbter Faden unter der Haut durchgezogen und Stich für Stich quasi eingestickt.

Bei anderen Techniken wird mit Schnitten auf der Haut eine Flächeneinteilung vorgegeben. Die Felder werden dann mit Figuren ausgefüllt. Ferner gibt es eine weniger präzise Technik, bei der mit einem scharfen Stein Linien und Kurven gezogen werden. Sie ermöglicht komplizierte Tätowierungen mit Punktreihen, Spiralen oder anderen Formen. Sie wurde in der europäischen Frühgeschichte und wird heute noch von nordamerikanischen Indianern praktiziert. In Indochina verwendet man die so genannte Beitel- oder Kammtechnik: Dabei bedient man sich einer Nadelreihe oder einer aus entsprechend geschliffenen Tier- oder Menschenknochen geformten Harke. Der Tätowierkünstler treibt dieses Instrument mit einem so genannten Malet, einem Schlagstock,

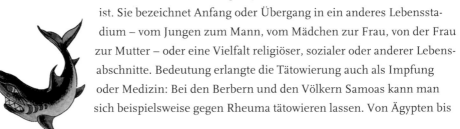

mit hoher Geschwindigkeit in die gestraffte Haut. Eine weitere Technik ist die japanische Methode, die sich einer Reihe von Stöcken mit Nadeln bedient, die zu einem Muster angeordnet sind. Für Details braucht man nur bis zu drei Nadeln, für die Linien dagegen mehrere und für farbige und schwarze Flächen schließlich eine große Anzahl an Nadeln.

POPEYE

Die elektrische Tätowiermaschine, die Samuel O'Reilly 1891 patentieren ließ, hat inzwischen immer mehr Verbreitung gefunden. Daneben findet man auch die Rotationstechnik, beispielsweise in Strafanstalten, bei der Kassettenrecorder oder ein Rasierapparat als Antrieb dienen – die Ergebnisse sind häufig verblüffend.

Soviel zum Wie. Was aber ist mit dem Warum? Anlass für eine Tätowierung können Trauer oder Freude, Sieg oder Niederlage sein. Manchmal hat das Tätowieren einen traditionell-religiösen Hintergrund, dann wieder ist es pure Lust, Ausdruck von Sadismus, Folterung oder Aberglaube. Es gibt viele Motivationen für das Tätowieren.

Bei Urvölkern diente die Tätowierung u. a. als Tarnung während der Jagd. Belegt sind Tätowierungen, die Jagdtrophäen zeigen oder dazu dienen, das Wohlwollen des Beutetieres zu erlangen. Auch ist in tätowierten Darstellungen die Jagd kannibalischer Völker bezeugt.

Ein anderes Motiv für Tätowierungen ist religiöser Art: Man will sich einen Platz im Himmel sichern und klärt seinen Gott mit Tätowierungen über die eigene Person auf. In Indien und in Tibet helfen Tätowierungen, schwierige Perioden im Leben zu meistern. Die Absicht, ein seelisches Leiden durch einen körperlichen Schmerz zu überwinden, kann sogar zu Verstümmelungen führen. So gedenkt man der Verstorbenen und verehrt sie durch ein tätowiertes »in memoriam«. In der westlichen Welt sind das tätowierte »Memento mori« und »in memoriam« ebenfalls geläufig. Die vielleicht bekannteste Form der Tätowierung ist jene, die Bestandteil von Initiationsriten ist. Sie bezeichnet Anfang oder Übergang in ein anderes Lebensstadium – vom Jungen zum Mann, vom Mädchen zur Frau, von der Frau zur Mutter – oder eine Vielfalt religiöser, sozialer oder anderer Lebensabschnitte. Bedeutung erlangte die Tätowierung auch als Impfung oder Medizin: Bei den Berbern und den Völkern Samoas kann man sich beispielsweise gegen Rheuma tätowieren lassen. Von Ägypten bis

Südafrika gibt es medizinische Tätowierungen, die gegen Augenkrankheiten oder Kopfschmerzen eingesetzt werden. Die Inuit und nordamerikanischen Indianer versahen die Haut mit Zeichen, um sich vor Krankheiten zu schützen. Die kunstvollen Narbentätowierungen bei den jungen Nubamädchen im Sudan und in anderen afrikanischen Gegenden sind nicht nur Schmuck, sondern auch eine traditionelle Form der Impfung: Kleine Wunden sollen das Immunsystem kräftigen.

Tätowierungen können helfen, bestimmte Eigenschaften zu erlangen, indem man genau diese an Vorfahren und Geistern rühmt und verehrt. Solche Tätowierungen greifen vor allem die Volks- und Stammesgeschichte auf. Tätowierungen fungieren als nichtsprachliche Kommunikation. Die Linien auf den Gesichtern von Inuit etwa findet man auch bei den Mentawai. Die Spiral- und Linientätowierungen auf den Gesichtern der Maori erzählen dem Eingeweihten unmissverständlich die Lebensgeschichte und die Eigenschaften des Trägers.

Anlass für eine Tätowierung kann auch die Absicht sein, den Feind in Angst und Schrecken zu versetzen oder den Gegner abzulenken, so etwa bei den Bewohnern der Marquesainseln, wo große, starr blickende Augen auf der Innenseite des Arms den Gegner für den Bruchteil einer Sekunde verunsichern sollen. Japanische Gangster, die so genannten Yakuza, legen während des berühmt-berüchtigten Glücksspiels mit Karten, dem Hanafuda, ihre Kimonos ab, um ihrem Gegner zu imponieren. Mike Tyson provoziert die Welt mit einer Tätowierung, die den verstorbenen »allwissenden« KP-Vorsitzenden Mao Zedong darstellt. Mickey Rourke bezweckt Gleiches mit seiner IRA-Tätowierung.

In sowjetischen Gefangenenlagern, den berüchtigten Gulags, wurden Schriftbänder von Schulter zu Schulter tätowiert, die etwa besagten: »Russland ohne die Roten« oder »Ich danke den Herren Kommunisten für meine glückliche Jugend«, bebildert mit einem Kind hinter Stacheldrahtzaun. Verbreitet waren auch Bauchtätowierungen, die Stalin beim Kopulieren mit einem Schwein darstellten. Eine Tätowierung kann so zur Form des Protests werden. Sie gibt die Kraft zum Überleben angesichts der täglichen Erniedrigung, sie ist Ausdruck eines freien Geistes in einem gefangenen Körper.

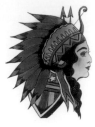

Eine andere Form der Tätowierung ist die erotische Verzierung, die den Körper sexuell interessanter macht. Das gilt ebenso für Lederfreaks und Sadomasochisten wie für die Sanften und Zärtlichen, ob Hetero oder Homo. Solche Tätowierungen signalisieren in Schrift und Symbol die sexuellen Vorlieben des Trägers.

Andere Tätowierungen sind persönliche Statements über Liebe und Freundschaft, über Patriotismus oder gegen Anpassung. Beispiele gibt es zur Genüge: »Made in Germany« gibt den Skinhead zu erkennen, »Mutter« den Familienbewussten, Namen erinnern an amouröse Abenteuer. Anarchismus und Outsidertum manifestieren sich in schockierenden Symbolen. Eines der berüchtigsten Zeichen setzt sich aus drei Punkten zwischen Daumen und Zeigefinger zusammen: »Mort aux vaches« – grob übersetzt »Tod den Bullen, der Polizei, der Justiz«.

Ferner können Tätowierungen persönliche Ereignisse dokumentieren: Pilger lassen die Ankunft an ihrer Pilgerstätte registrieren. Seeleute schmücken sich mit Hafenansichten oder Darstellungen des Kap Hoorn. Soldaten verewigen ihre Schlachten auf der Haut, so beispielsweise die Vietnamveteranen »ihr« Saigon.

Etwas anderes ist es, wenn eine Gruppenzugehörigkeit ausgedrückt werden soll. Bei primitiven Stämmen trägt man die Stammesabzeichen, das Totem. Die Jaruba in Nigeria bringen ihre Gruppenzugehörigkeit durch Narben zum Ausdruck, und auch die chinesischen Triaden, die Hells Angels und die Straßenbanden in den amerikanischen Großstädten haben eigene Tätowierungen.

Selbst die Werbebranche setzt heutzutage (unechte) Tätowierungen ein. Die Tätowierung wird einfach auf die Haut gemalt. Im Alltag sind Tätowierungen von Markenzeichen oder Logos nicht ungewöhnlich: Harley Davidson, Jack Daniels, Lucky Strike, Chanel ... Beliebt ist auch das Lacoste-Krokodil auf der Brust.

Tätowierungen zur medizinischen Information sind heute noch beim amerikanischen und englischen Militär verbreitet. Ich selber habe einmal vorgeschlagen, Organspender mit unsichtbarer Tinte an einer vereinbarten Stelle zu tätowieren, so dass der Arzt diese mit ultraviolettem Licht sofort erkennen kann.

Die aufgezwungene Tätowierung als Strafe, als Brandzeichen ist zum Glück kaum noch gebräuchlich. Zu erinnern ist an die Regis-

triernummern der KZ-Insassen. Die Tätowierungen dienten nicht nur den Lagerverwaltern, sie waren auch Teil einer Strategie der Dehumanisierung.

Schließlich sei noch die Tätowierung aus kosmetischen Gründen erwähnt: das Entfernen von Pigmentflecken, das Überdecken oder Färben von Narben im passenden Hautton.

In der industrialisierten Welt werden mit Tätowierungen Kriminelle, Seeleute und Huren assoziiert oder auch die Exzentriker der High Society. Um die Jahrhundertwende war die gesamte Elite tätowiert, vom Zaren und der Zarin bis zu den amerikanischen Oberen Zehntausend. Gleiches gilt auch für die heutige Elite, für Filmstars, die Kings of Rock'n'Roll und Künstler, die das Leben, die Kunst, die Mode oder die Moral beeinflussen: Sean Connery, Dennis Hopper, Whoopi Goldberg, Johnny Depp, Julia Roberts, David Bowie, die Red Hot Chili Peppers, Nirvana, die Smashing Pumpkins – sie alle tragen Tätowierungen.

Die Qualität der Tätowierung hängt ab vom kulturellen und wirtschaftlichen Entwicklungsstand. Eine reiche spirituelle und mythische Gedankenwelt ist Voraussetzung für vielfältige Kunst- und Kulturformen. Bei vielen primitiven Völkern, die nur eine mündlich tradierte Geschichte kennen, kann man anhand der Tätowierungen die Stammesgeschichte zurückverfolgen – manchmal durch bis zu 90 oder 100 Generationen. Ethnografische Studien haben belegt, dass mit dem Aufkommen von Siedlungen, Landbau und hierarchischen Strukturen Höhepunkte primitiver Kunstformen entstanden sind. Solche Völker ließen sich tätowieren und tun dies nach wie vor, weil ihr Zusammenleben in Bezug auf Hierarchie, Religion, Ansehen und Heldentum komplex ist. Die gesamte Kunst des Pazifikraums z. B. stammt von Völkern, die auch in der Kunst des Tätowierens bewandert sind. Hier lässt sich belegen, dass Tätowierungen Ausdruck einer hoch entwickelten Gemeinschaft und Kultur sind.

Henk Schiffmacher

Histoire et Technique du Tatouage

En tant qu'expression artistique, le tatouage est aussi éphémère que la vie humaine. Il disparaît avec celui ou celle qui le porte. Les peintures rupestres, les sculptures et les monuments témoignent en revanche de la culture des civilisations disparues.

Le tatouage provoque les réactions les plus diverses et l'on s'interroge sur son sens et sa finalité. Or, cet aspect du phénomène est en général mal ou insuffisamment traité. Certes, il existe toute une littérature ethnographique sur le tatouage tel qu'il est pratiqué par de lointaines peuplades « primitives », mais le phénomène n'est guère appréhendé dans sa totalité. Comme le faisait déjà remarquer Darwin, il n'existe sur cette planète aucun peuple qui ne connaisse cette pratique.

La technique du tatouage n'a guère évolué au cours des siècles : elle consiste en gros à introduire des pigments sous la peau. En revanche, on note des différences de qualité qui dépendent des outils d'une part et du souci esthétique de l'autre : le tatouage doit être finement tracé, et les lignes doivent être minces et régulières. A cela s'ajoute le savoir-faire : appliquer la bonne quantité de pigments, pénétrer la peau suffisamment mais pas trop pour éviter de laisser des cicatrices. Certaines populations « primitives » ont mis au point des techniques étonnantes. C'est le cas des Inuits qui passent sous la peau, à l'aide d'une aiguille, un fil enduit de noir de fumée, brodant pour ainsi dire leurs tatouages au point par point.

On peut aussi inciser la peau pour délimiter des surfaces précises. Chaque compartiment est ensuite rempli de motifs. Une autre technique, moins précise, consiste à tracer des lignes et des courbes avec une pierre à bord tranchant. Permettant de réaliser des tatouages complexes formés de nombreux points, spirales et autres figures, elle était déjà connue en Europe pendant la préhistoire et elle est toujours pratiquée par les Amérindiens (Indiens d'Amérique du Nord). En Extrême-Orient, on se sert aussi d'une sorte de

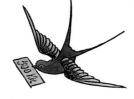

peigne formé d'un manche hérissé d'aiguilles ou de pointes d'os ou d'ivoire. Le tatoueur tient cet instrument d'une main et le frappe vivement avec un maillet qu'il tient dans l'autre main. Les pointes pénètrent ainsi dans la peau, que des assistants maintiennent tendue.

Une autre technique est celle qu'utilisent les Japonais en se servant d'une série de baguettes à aiguilles réunies pour former un motif. Les motifs simples n'exigent que trois aiguilles, il en faut plus pour les lignes ou des surfaces noircies et colorées.

La machine à tatouer électrique, brevetée pour la première fois en 1891 par Samuel O'Reilly, n'a cessé depuis de se populariser. Outre ces appareils à mouvement vertical, il existe aussi des machines à mouvement circulaire que l'on trouve dans les prisons, où elles peuvent être raccordées à un magnétophone, un rasoir ou une brosse à dents électrique. Malgré tout, les résultats sont souvent étonnants.

Passons maintenant aux raisons qui incitent à se faire tatouer. Le tatouage peut être exécuté à l'occasion d'un deuil ou d'un événement heureux, d'une victoire ou d'une défaite. Il se pratique dans un cadre traditionnel et religieux, mais aussi par sadisme ou superstition. Il existe une foule de raisons pour se faire tatouer. La première raison à laquelle on pense est le camouflage pour la chasse. L'existence de tatouages représentant des trophées ou des scènes de chasses fructueuses est attestée. On trouve également des scènes de chasses cannibales.

Le tatouage peut également avoir une fonction religieuse. Celui qui veut s'assurer une place au Ciel attire ainsi l'attention du dieu sur sa personne. En Inde et au Tibet, les tatouages aident à traverser les périodes difficiles de la vie. On essaie de chasser un traumatisme affectif en se soumettant à des sévices physiques qui peuvent aller jusqu'à la mutilation. C'est une façon de garder présent le souvenir d'un mort ou de l'honorer par un tatouage « in memoriam ». Le tatouage « memento mori » ou « in memoriam » est tout aussi répandu dans le monde occidental.

Dans de nombreuses régions du monde – et c'est là peut-être son aspect le plus connu –, le tatouage est un élément constitutif des rites d'initiation. Il représente le passage à un autre stade de la vie – du garçon à l'homme, de la fillette à la femme, de la femme à la mère – et marque du même coup les phases religieuses et sociales de l'existence. Les tatouages

jouent également un rôle vaccinal ou thérapeutique. Chez les Berbères et d'autres peuples, par exemple à Samoa, on peut se faire tatouer contre les rhumatismes. De l'Egypte à l'Afrique du Sud, on retrouve ces tatouages curatifs, fréquemment employés contre les affections oculaires et les maux de tête. Les Inuits et les Amérindiens se gravaient eux aussi sur la peau des signes destinés à les protéger des maladies. Les scarifications des jeunes filles noubas du Soudan ou dans d'autres pays d'Afrique n'ont pas qu'une fonction esthétique. Elles sont aussi une forme traditionnelle de vaccin. En pratiquant de petites incisions, on renforce le système immunitaire.

On peut s'efforcer d'acquérir les qualités d'un ancêtre ou d'un esprit en s'en faisant tatouer la représentation symbolique sur la peau : le tatoueur choisit alors le motif dans l'histoire du peuple ou de la tribu.

Le tatouage est un langage : sur les îles Mentawei, par exemple, on retrouve les lignes qui, sur les visages inuits, rappellent le souvenir d'un meurtre. Les spirales et les lignes tatouées sur les visages des Maoris évoquent clairement pour l'initié le passé et les qualités de celui qui les porte. Le tatouage sert aussi tout simplement à effrayer l'ennemi. Lors d'un combat, le tatouage doit détourner l'attention de l'adversaire et aux Iles Marquises, certains tatouages revêtent cette fonction. De grands yeux gravés sur la face intérieure du bras sont censés déstabiliser l'adversaire pendant quelques secondes. Lors des parties de « hanafuda », un jeu de cartes pratiqué illégalement dans des tripots, les gangsters japonais, les yakusas, retirent leur kimono pour impressionner leurs adversaires avec leurs tatouages. Mike Tyson joue les provocateurs avec son tatouage de Mao Tsé-Tung. Mickey Rourke en fait autant avec son tatouage de l'IRA.

Dans les camps de prisonniers russes, les fameux goulags, nombre d'épaules arboraient des inscriptions du type : « Une Russie sans les Rouges » ou « Je remercie mes maîtres communistes pour cette jeunesse heureuse », agrémentées d'un dessin représentant un enfant derrière des barbelés. Fréquents également, les tatouages sur l'abdomen qui représentaient Staline forniquant avec un cochon. Le tatouage constitue dans ce cas une forme extrême de contestation. Il donne la force de survivre, de s'affirmer face aux humiliations quotidiennes, il est la preuve que l'esprit est libre, même si le corps est prisonnier.

Le tatouage peut également servir de parure érotique en rendant le corps

plus attrayant sexuellement. C'est la fonction que lui assignent les amateurs de cuir, les adeptes des rapports sado-maso ou ceux qui préfèrent la douceur et la tendresse, qu'ils soient hétérosexuels ou homosexuels. Ces inscriptions ou symboles signalent ainsi les préférences sexuelles du tatoué.

Les tatouages peuvent également délivrer des messages d'amour ou d'amitié, des formules patriotiques ou de révolte. Les exemples ne manquent pas : « Made in England » ou « Germany » pour les skinheads nationalistes ; « Mutter », « mom » et « maman » pour des fervents de la famille. Les allusions à des aventures amoureuses ne sont pas rares non plus. L'anarchisme et la révolte s'expriment souvent à travers des symboles violents. Parmi les signes les plus connus, citons les trois points tatoués, entre le pouce et l'index. Ils signifient « Mort aux vaches » (en clair : aux policiers).

Les tatouages peuvent aussi marquer certains événements personnels : les pèlerins se font tatouer en arrivant sur les lieux du pèlerinage. Les marins arborent l'image de « leur » port ou illustrent le passage du Cap Horn. Les soldats, eux, se font tatouer le nom des batailles auxquelles ils ont participé, comme Saigon pour les anciens combattants du Vietnam.

Mais le tatouage peut aussi signer l'appartenance à un groupe. Chez les peuples primitifs, on porte le signe de sa tribu, le totem. Les scarifications des Yorubas du Nigeria indiquent l'appartenance à un clan de la même façon que les tatouages des Hells Angels ou des bandes de rue des grandes villes américaines, et les signes tatoués des triades chinoise.

Les tatouages qui apparaissent aujourd'hui fréquemment dans la publicité sont en général simplement peints sur la peau le temps de prendre la photo. Mais il n'est pas rare que des fans se fassent tatouer leur marque préférée : Harley Davidson, Jack Daniels, Lucky Strike, Chanel... Parmi les grands classiques, citons aussi les crocodiles Lacoste tatoués sur la poitrine.

Les tatouages servant à donner des indications médicales sont encore répandus dans les armées américaine et anglaise. J'ai proposé de faire tatouer les donneurs d'organes à l'encre invisible, en un endroit convenu, de façon à ce qu'un médecin puisse reconnaître rapidement le tatouage aux ultraviolets.

Heureusement, le tatouage n'est plus guère utilisé pour châtier ou marquer les hommes, comme ce fut le cas pour les numéros d'immatri-

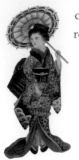

culation dans les camps de concentration. Ils ne servaient pas seulement à recenser les prisonniers, mais surtout à les humilier.

Enfin, les tatouages peuvent relayer les produits de beauté et servir à dissimuler des taches ou à dissimuler une cicatrice avec un tatouage de la couleur de la peau.

Dans le monde industrialisé, le tatouage est généralement associé aux classes défavorisées – délinquants, marins, prostituées – ou à l'inverse aux excentriques de la haute société. Au début du siècle, les tatouages étaient très répandus dans l'élite : le tsar et la tsarine, les familles américaines les plus riches. Il en va de même pour les célébrités d'aujourd'hui : les vedettes du cinéma, les chanteurs de rock et d'innombrables artistes portent des tatouages. Sean Connery, Dennis Hopper, Whoopi Goldberg, Johnny Depp, Julia Roberts, David Bowie, les Red Hot Chili Peppers, Nirvana ou les Smashing Pumpkins influencent la vie, l'art, la mode, la morale.

La qualité du tatouage dépend du niveau économique et culturel d'une société. Une pensée mythique et spirituelle riche entraîne l'épanouissement de toute une variété de formes artistiques et culturelles. Chez beaucoup de peuples primitifs qui ne transmettent leur histoire qu'oralement, on peut remonter à 90 ou 100 générations grâce aux tatouages. Des études ethnographiques ont prouvé que les plus belles formes de l'art primitif étaient apparues chez les peuples qui construisaient des maisons, pratiquaient l'agriculture et vivaient au sein de structures hiérarchisées. Dans la région Pacifique, l'art est également le fait de peuples «tatoueurs». En Nouvelle-Zélande, les Maoris ont porté l'art du tatouage à la perfection. Ils nous montrent ainsi que le marquage du corps témoigne d'une civilisation très évoluée.

Henk Schiffmacher

The Tattoo Museum Amsterdam, The Netherlands, 1996

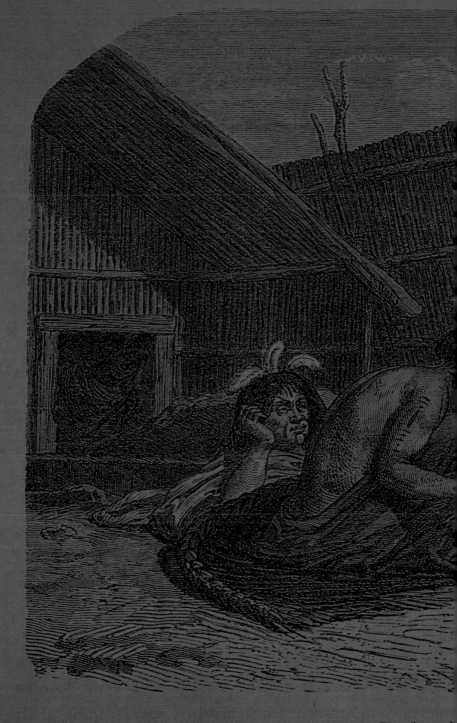

Tatoëeren en I

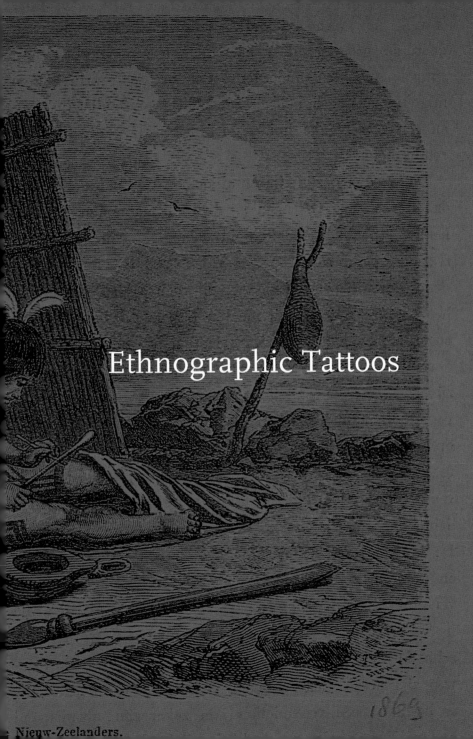

Ethnographic Tattoos

Nieuw-Zeelanders.

1869

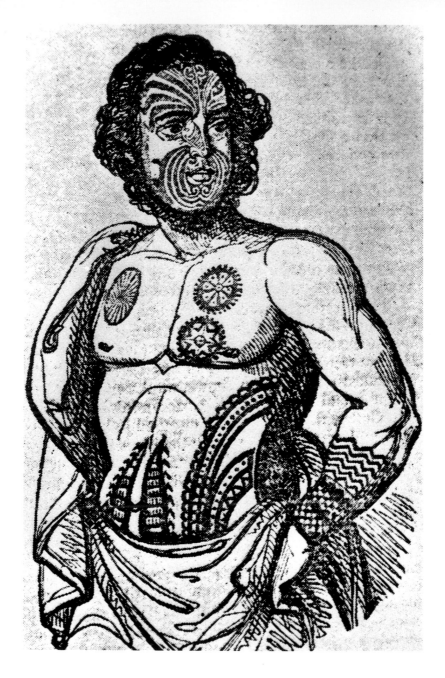

John Rutherford Tattooed by Maoris, 1828

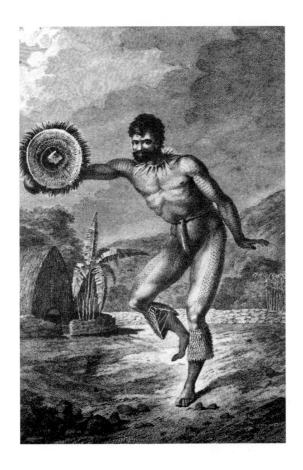

Hula Dancer, Hawaii, 1784

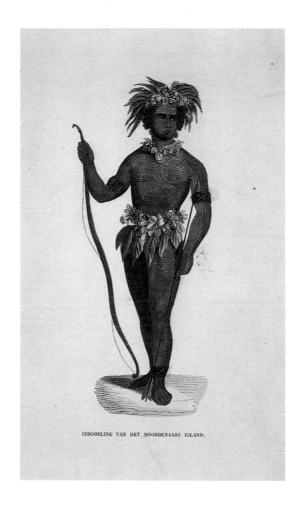

INBOORLING VAN HET MOORDENAARS EILAND.

Native, Murderer's Island

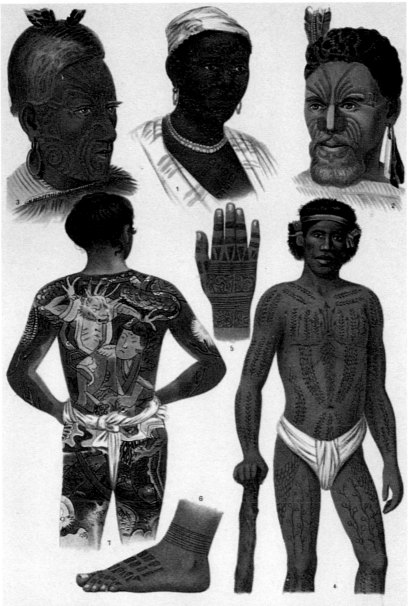

1. Negerin. — 2. Hoofd Hiriti-Paevata (Nieuw-Zeeland). — 3. Koning Tauhiao (Nieuw-Zeeland). — 4. Bewoner der Carolinen. — 5 en 6. Hand en voet van een Dajak van Borneo. — 7. Japannees.

Natives, New Zealand, Caroline Islands, Borneo, and Japan

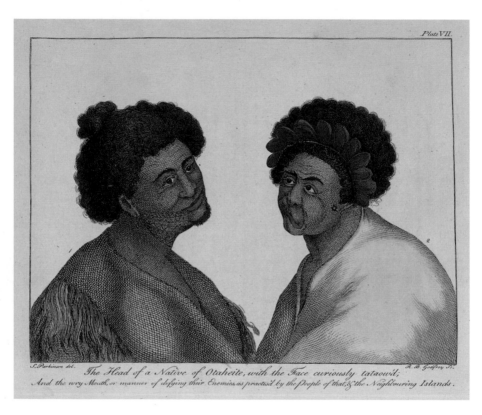

Plate VII.

S. Parkinson del. R. B. Godfrey Sc.

The Head of a Native of Otaheite, with the Face curiously tataow'd;
And the wry Mouth, or manner of defying their Enemies, as practised by the People of that, & the Neighbouring Islands.

Natives, Otaheite, 1773

Prince Constantine, Albania, about 1870

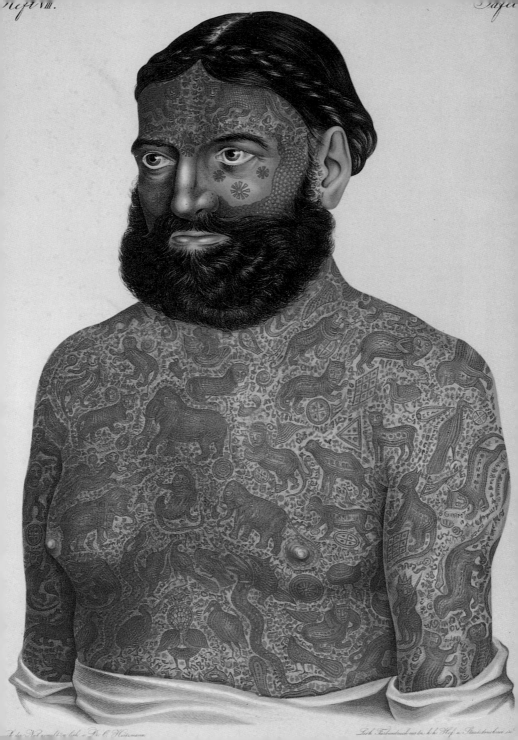

Lith. Farbendruck aus der k.k. Hof u. Staatsdruckerei in

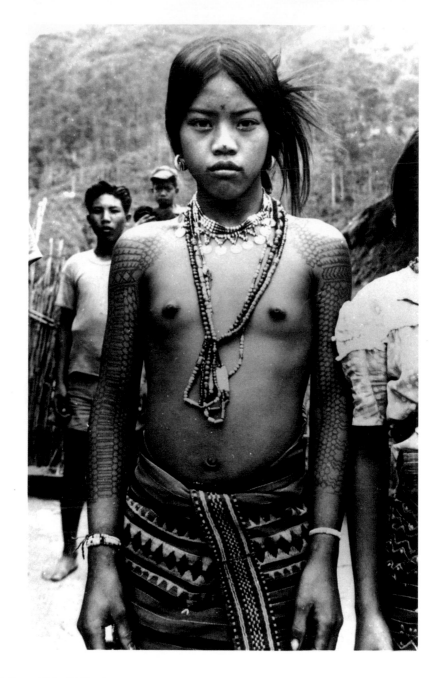

Kalinga Girls, Philippines, 1930s

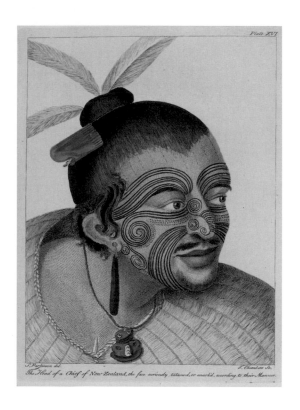

Maori, New Zealand, about 1770

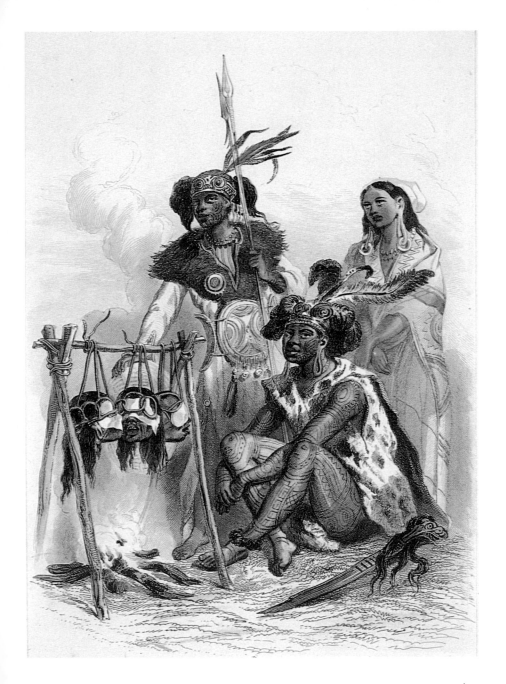

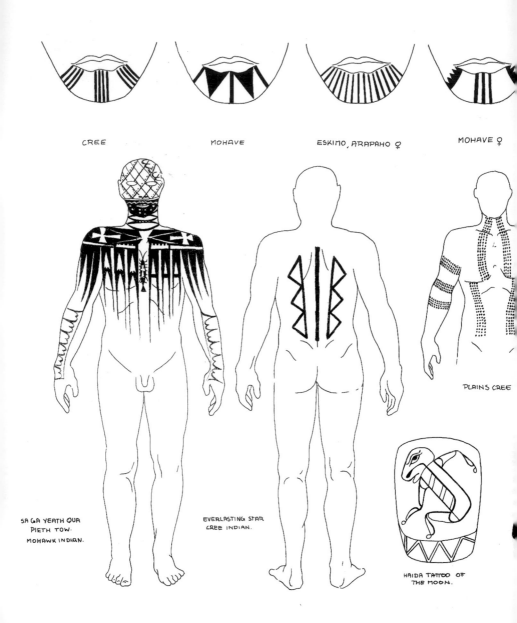

CREE MOHAVE ESKIMO, ARAPAHO ♀ MOHAVE ♀

PLAINS CREE

SA GA YEATH QUA
PIETH TOW.
MOHAWK INDIAN.

EVERLASTING STAR
CREE INDIAN.

HAIDA TATTOO OF
THE MOON.

North American Tattoo Designs by Henk Schiffmacher, Amsterdam, The Netherlands

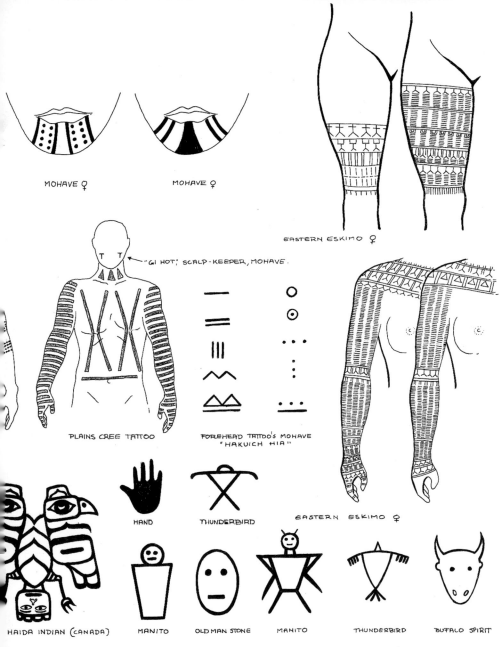

MOHAVE ♀

MOHAVE ♀

EASTERN ESKIMO ♀

"GI HOT" SCALP-KEEPER, MOHAVE.

PLAINS CREE TATTOO

FOREHEAD TATTOO'S MOHAVE
"HAKUICH HIA"

EASTERN ESKIMO ♀

HAND

THUNDERBIRD

HAIDA INDIAN (CANADA)

MANITO

OLD MAN STONE

MANITO

THUNDERBIRD

BUFALO SPIRIT

CREE INDIAN TATTOO'S

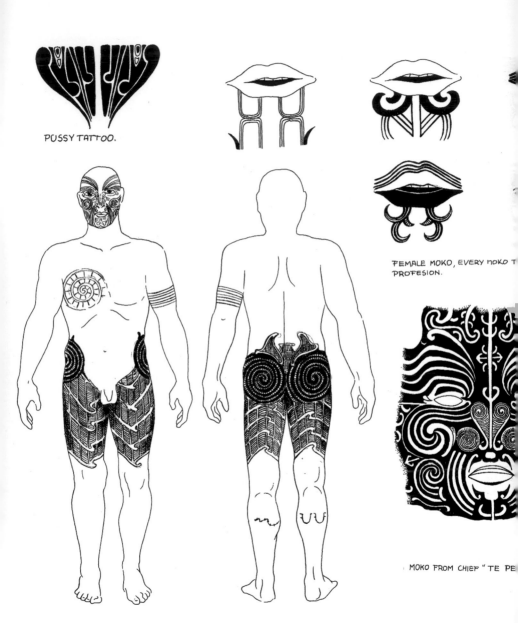

PUSSY TATTOO.

FEMALE MOKO, EVERY MOKO T
PROFESION.

MOKO FROM CHIEF " TE PE

Maori Tattoo Designs

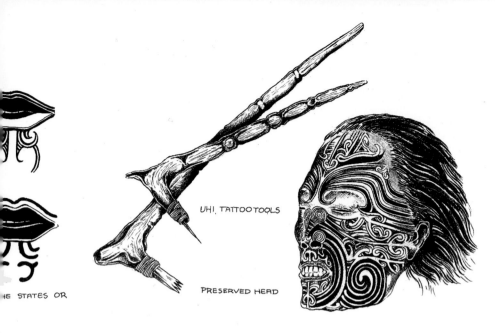

UHI, TATTOO TOOLS

PRESERVED HEAD

IE STATES OR

THE DIVISIONS OF THE MALE
MAORI FACE.

① NGAKAIPIKIRAU. RANK
② NGUNGA, POSITION IN LIFE.
③ UIRERE, LINES OF RANK
 BY HAPU.
④ UMA, FIRST OR SECOND
 MARRIAGE
⑤ RAURAU, SIGNATURE
⑥ TAIOHOU, WORK
⑦ WAIRUA, MANA **
⑧ TAITOTO, POSITION
 AT BIRD.

* RANK,
 SOCIAL STATUS.

** POWER, PRESTIGE AND WORTH
 WAS CENTRAL IN THE WHOLE
 SYSTEEM, COMES FROM THE
 GOD'S.

E "

TRACING FROM A THIGH SKIN. REDUCED TO
TWO-THIRDS OF LIFE SIZE.

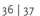

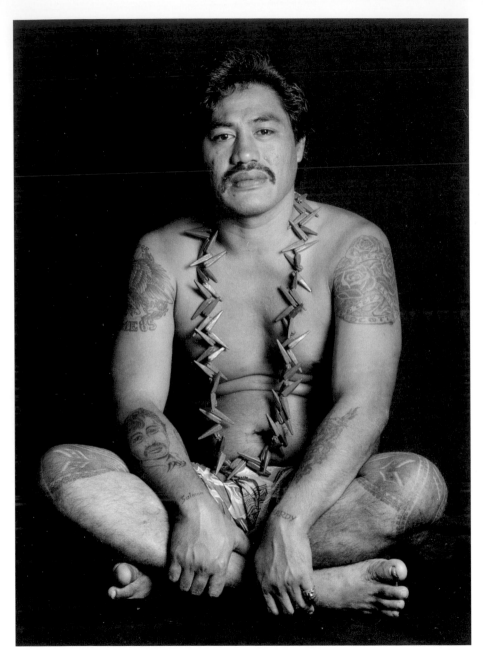

Tattoo Master Petelo Suluape, Samoa
Photo: Paul de Bruin, Amsterdam, The Netherlands, 1990

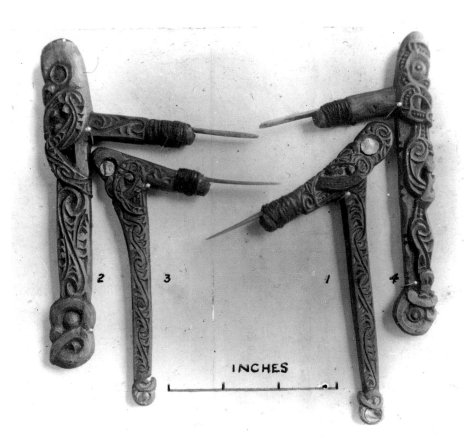

INCHES

Maori Tattooing Chisels, New Zealand

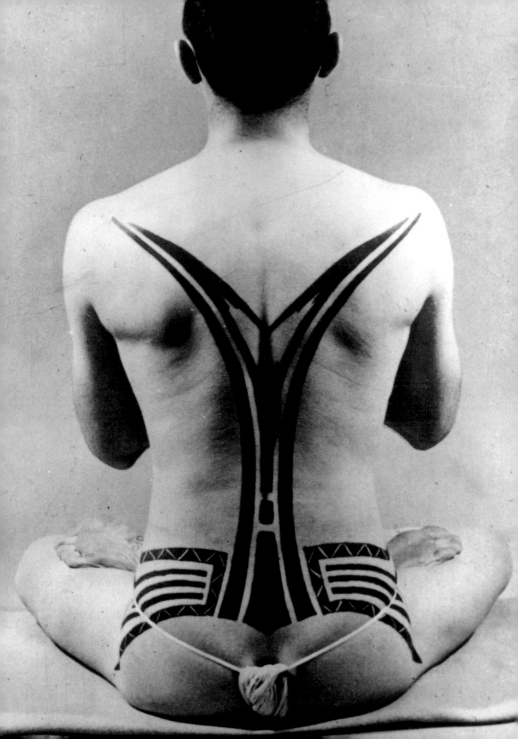

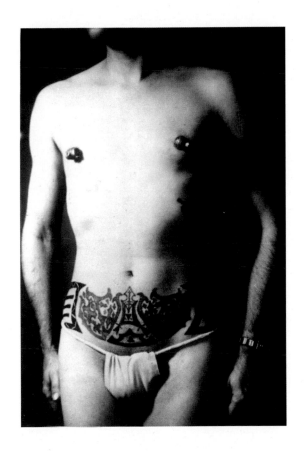

Fakir Mustafar, USA, 1960s

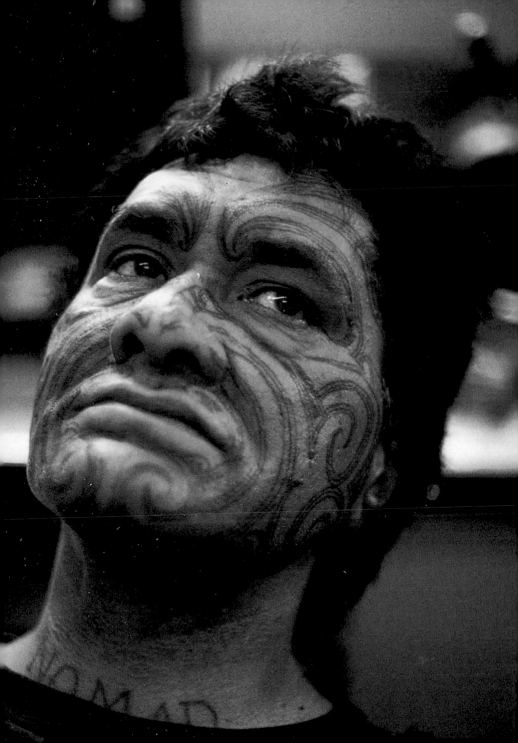

The names appearing in the captions are those of the tattoo artists.

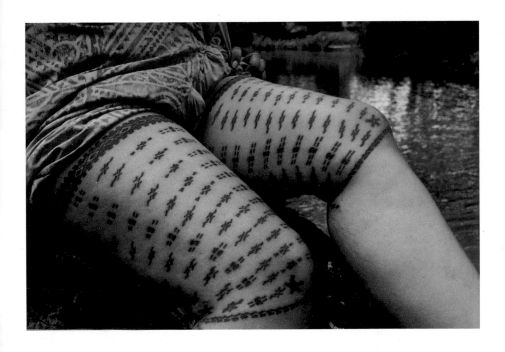

Petelo Suluape, Samoa
Photo: P. Steve

Graham Cavanaugh, Auckland, New Zealand
Photo: Gilles Frenken, 1995

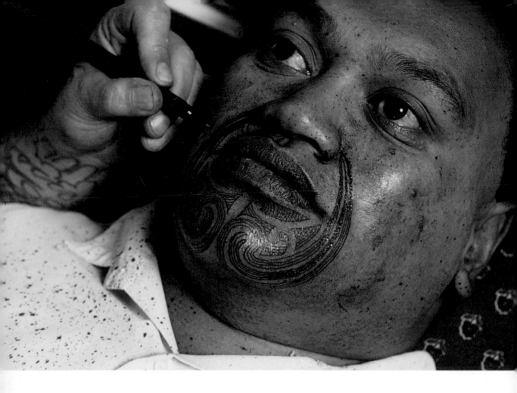

Graham Cavanaugh Tattooing a Moko, Auckland, New Zealand

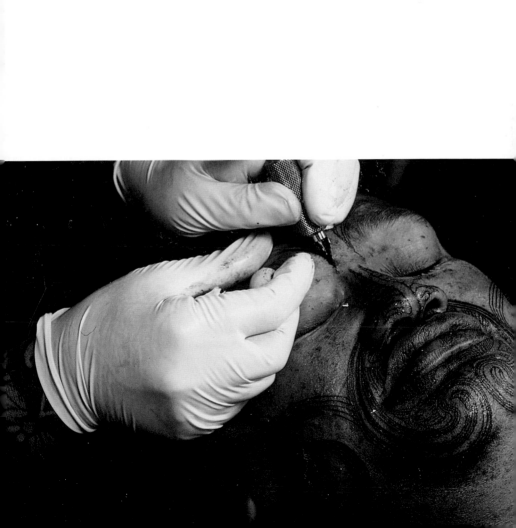

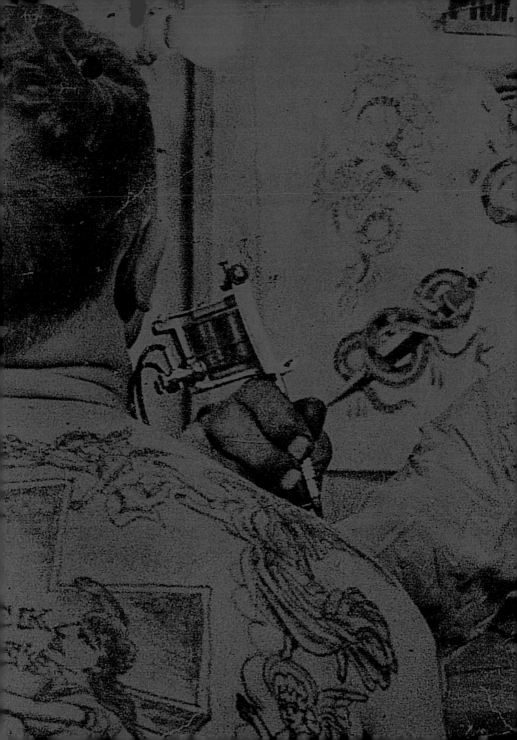

Classical Tattoo Designs

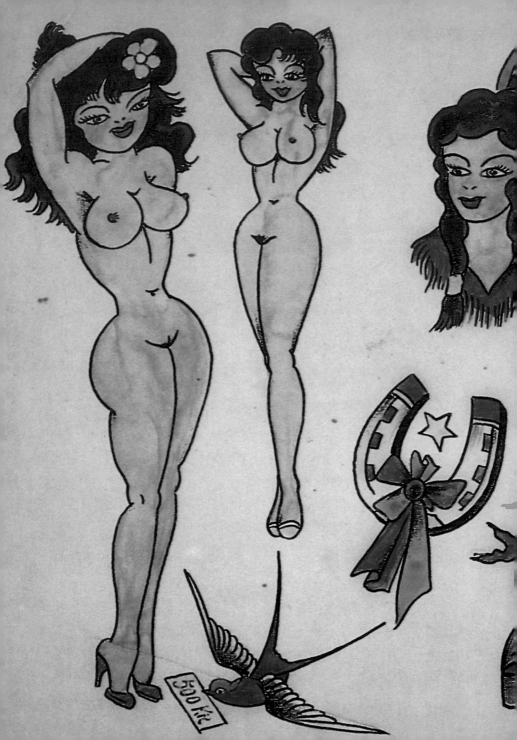

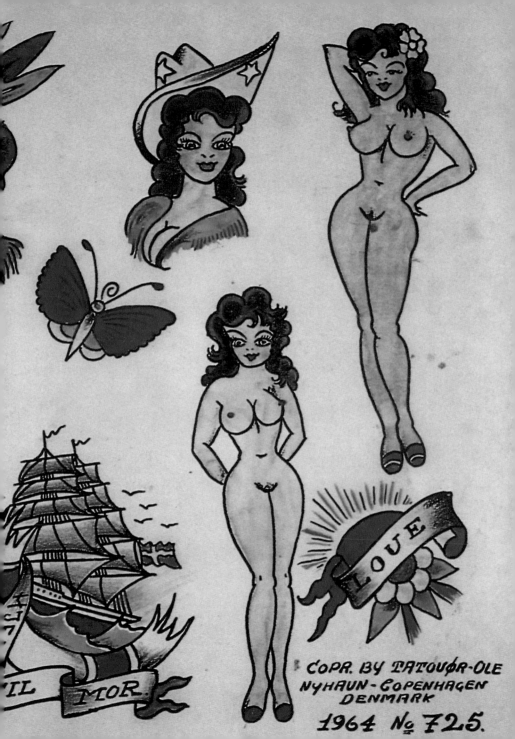

COPR. BY TATOUØR-OLE
NYHAUN - COPENHAGEN
DENMARK
1964 № 725.

IL MOR

LOVE

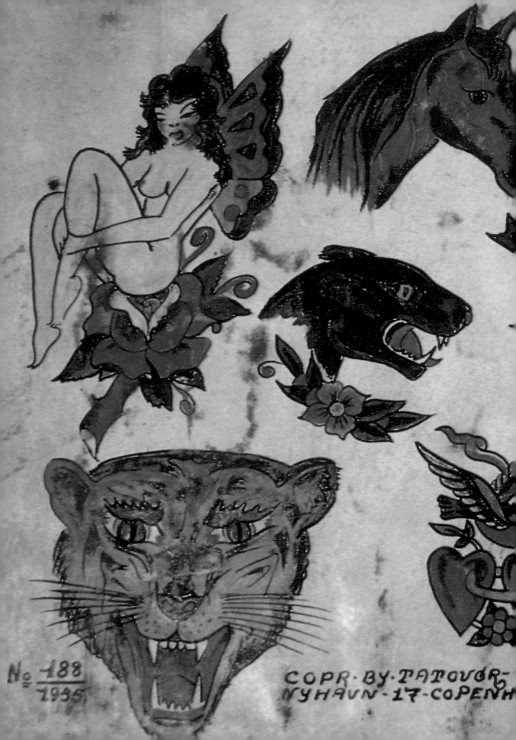

No 188/1995

COPR·BY·TATOVOR-
NYHAVN·17·COPENH

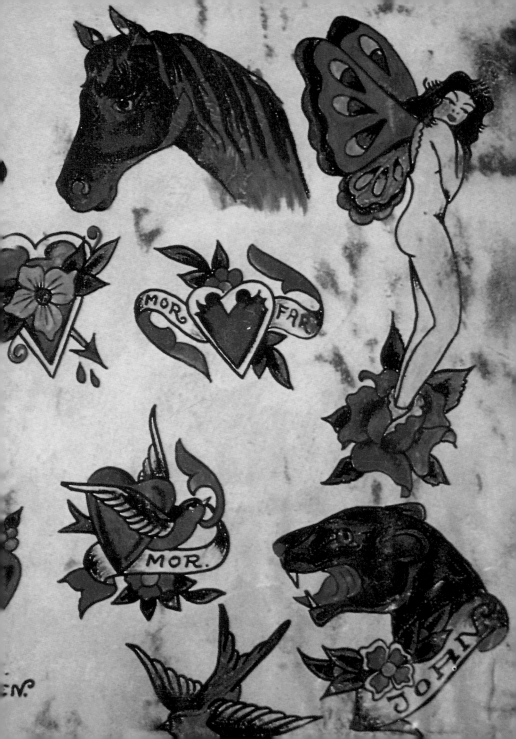

Page 46 | 47:
Charles Wagner at Work, New York, USA
(New York), 1920s

Page 48 | 49:
"Tatovør" Ole Hansen, Copenhagen, Denmark, 1964

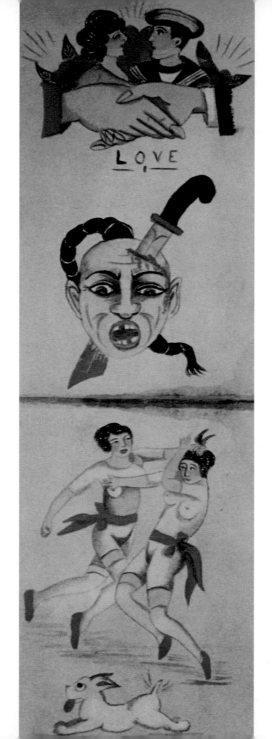

LOVE

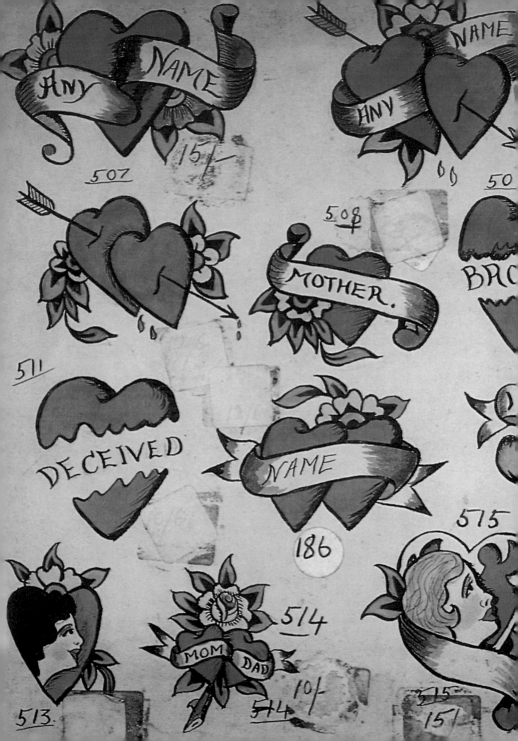

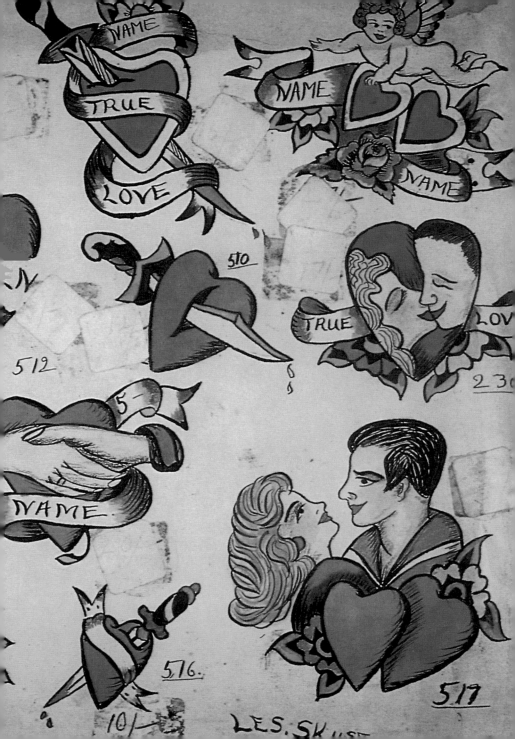

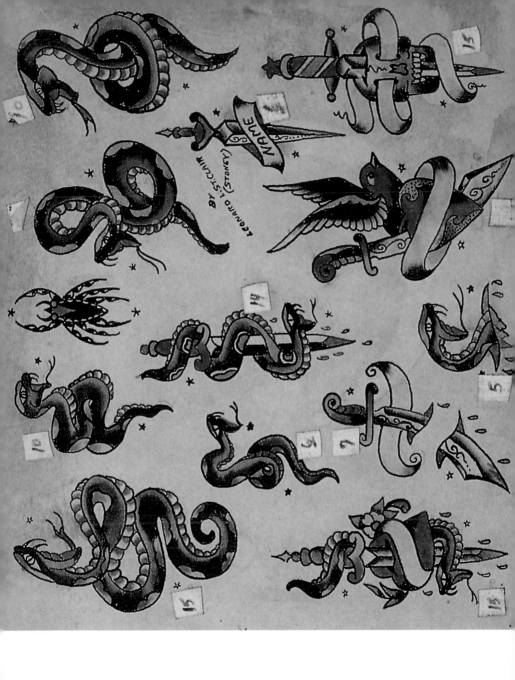

BY ST-CLAIR

LEONARD V. (STONEY)

NAME

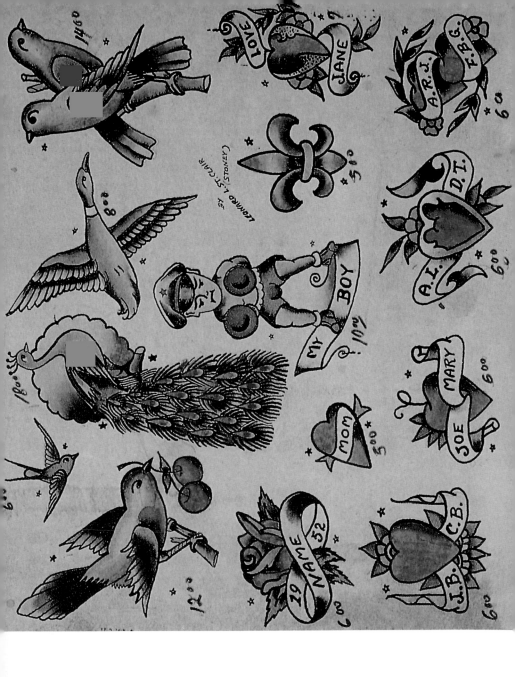

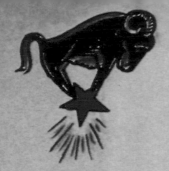

21-3-20-4.

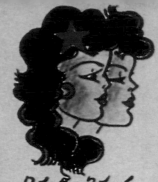

21-5-21-6.

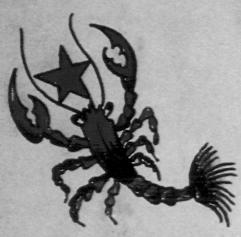

22-6-22-7

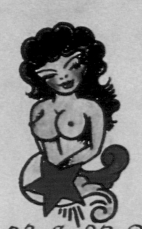

23-8-23-9.

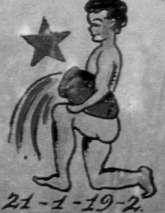

21-1-19-2.

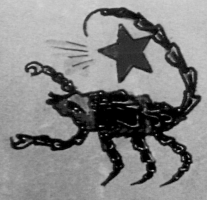

23-10-21-11.

400-1962.

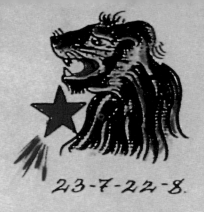

23-7-22-8.

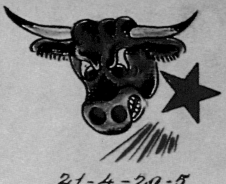

21-4-20-5.

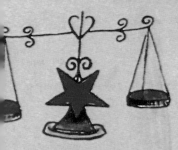

24-9-23-10.

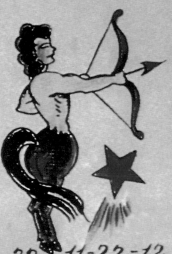

22-11-22-12

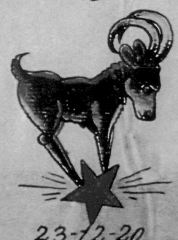

23-12-20.

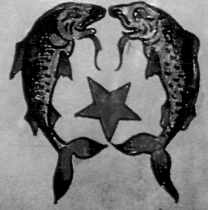

20-2-20-3.

COPR BY TATOUOR-OL

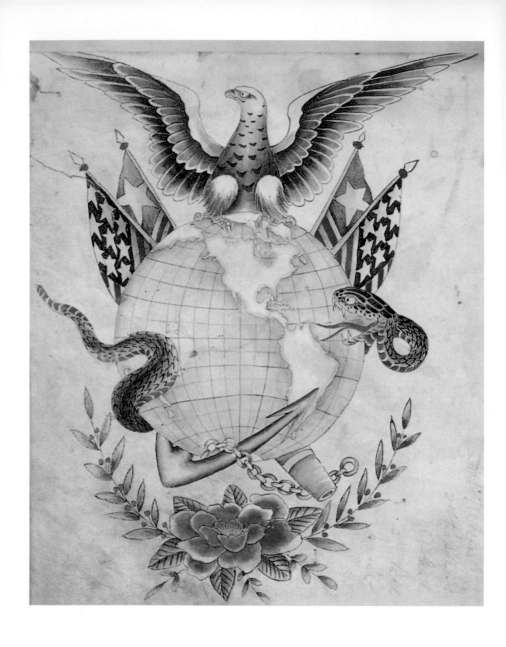

"Tatovør" Ole Hansen, Copenhagen, Denmark, 1962

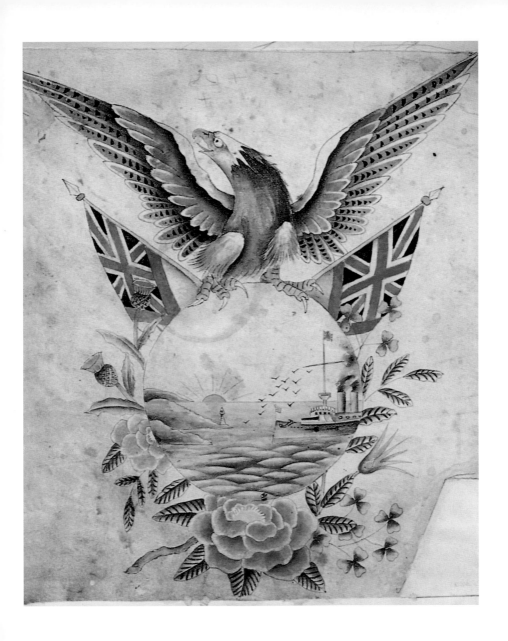

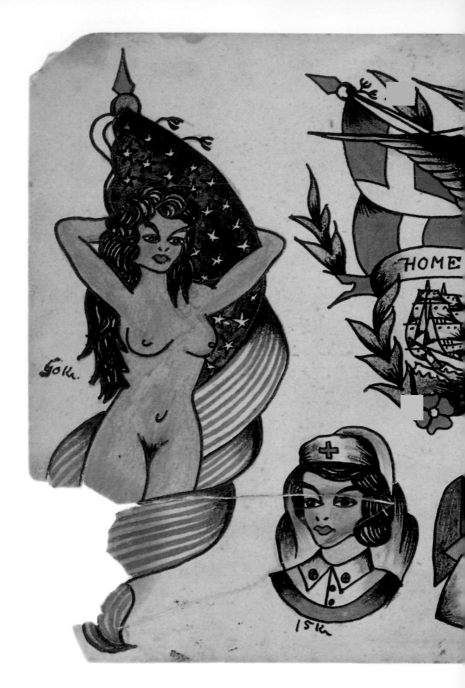

Tattoo-Jack, Copenhagen, Denmark, 1950s

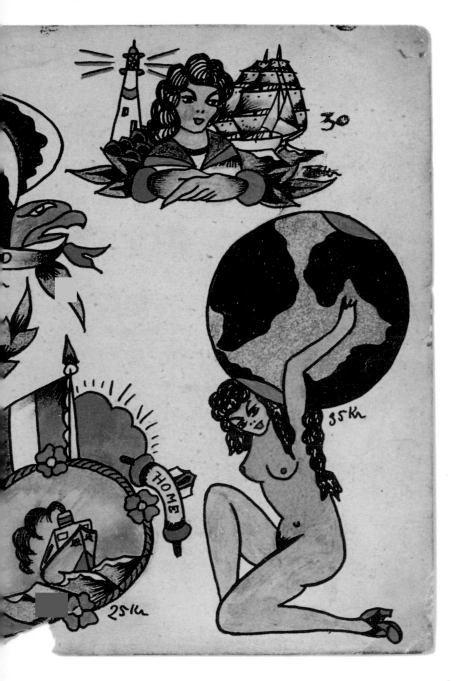

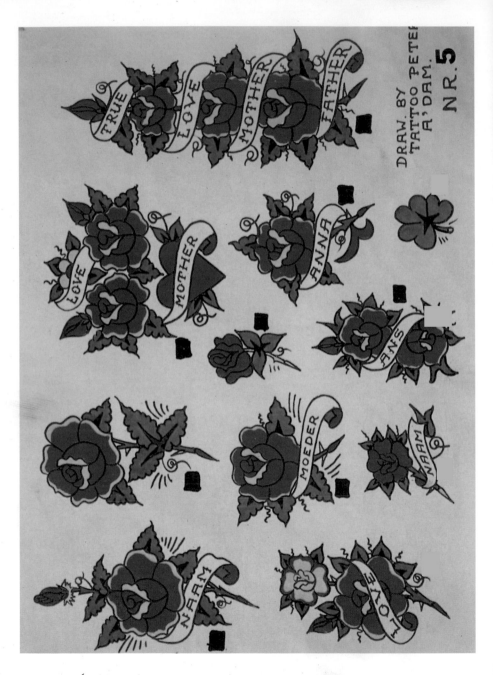

Tattoo Peter, Amsterdam, The Netherlands, 1950s

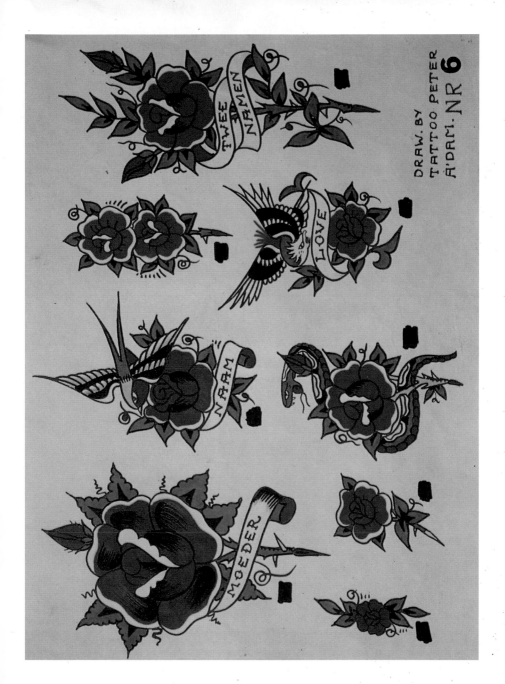

TWEE NAMEN

DRAW. BY
TATTOO PETER
A'DAM. NR 6

LOVE

NAAM

MOEDER

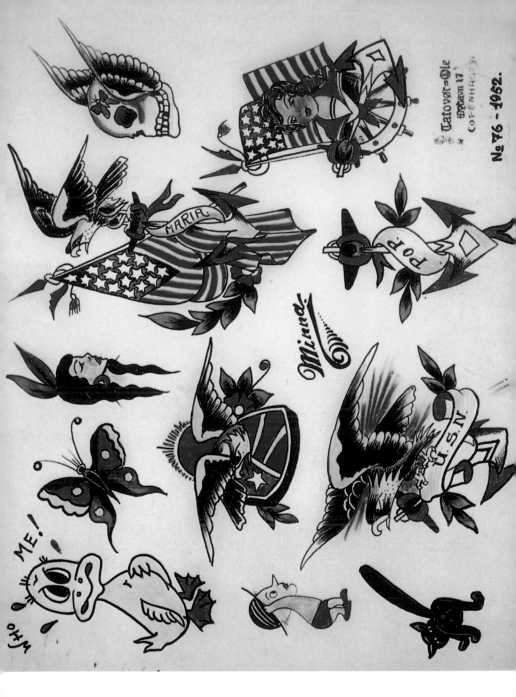

"Tatovør" Ole Hansen, Copenhagen, Denmark, 1952

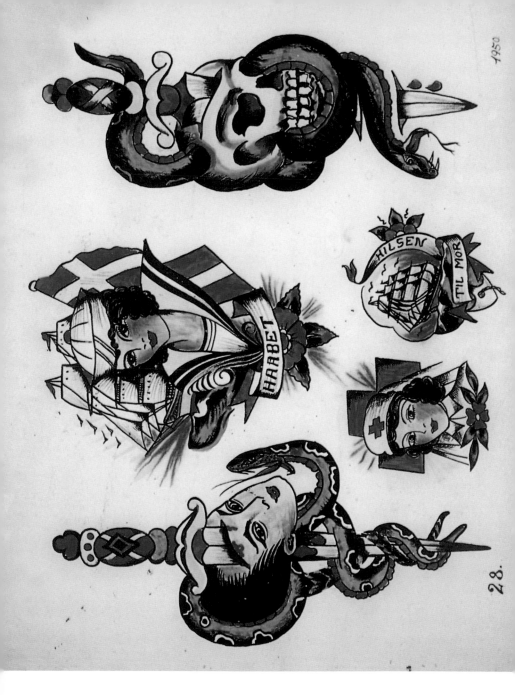

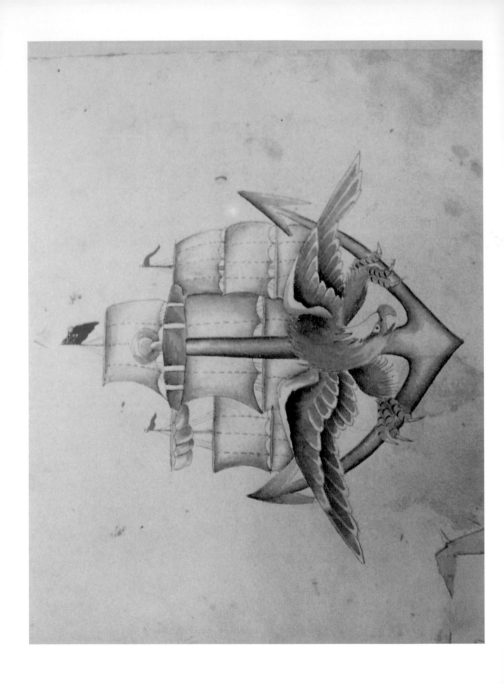

George Burchett, London, Great Britain, 1920s

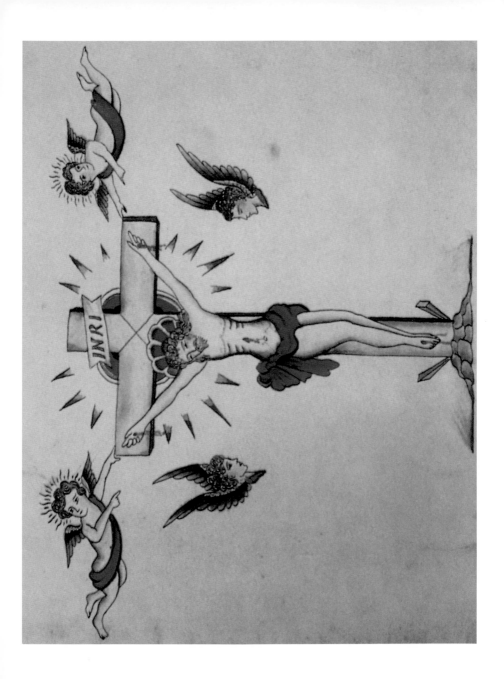

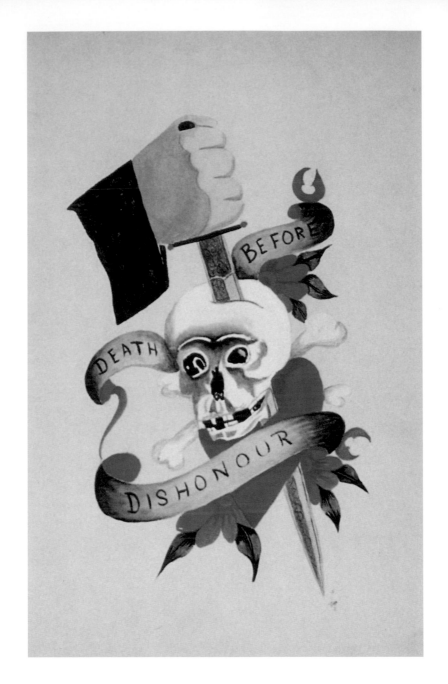

Joseph Hartley, Bristol, Great Britain, 1930s

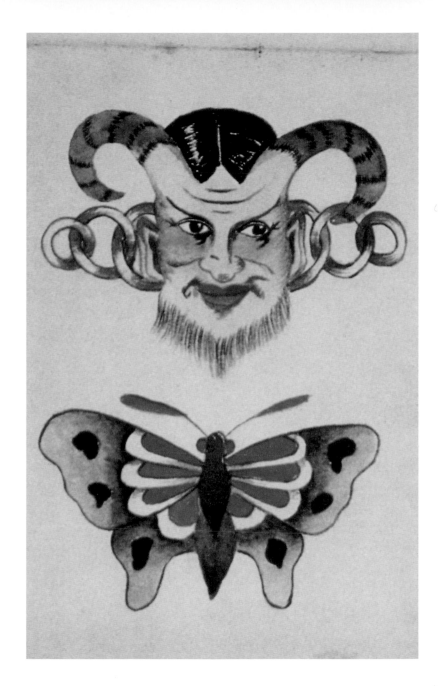

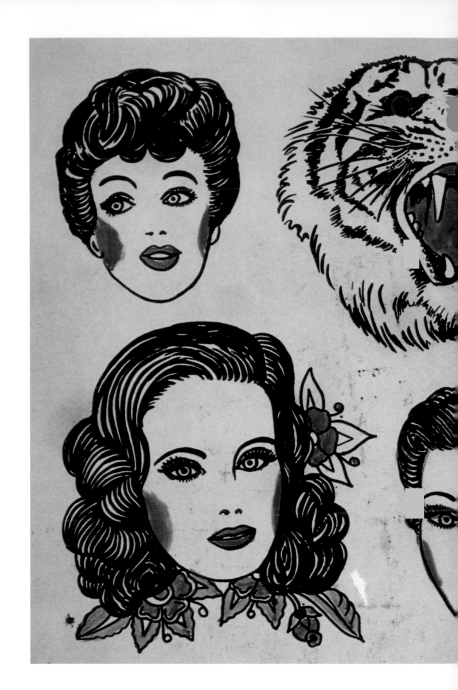

Tattoo-Jack, Copenhagen, Denmark, 1951

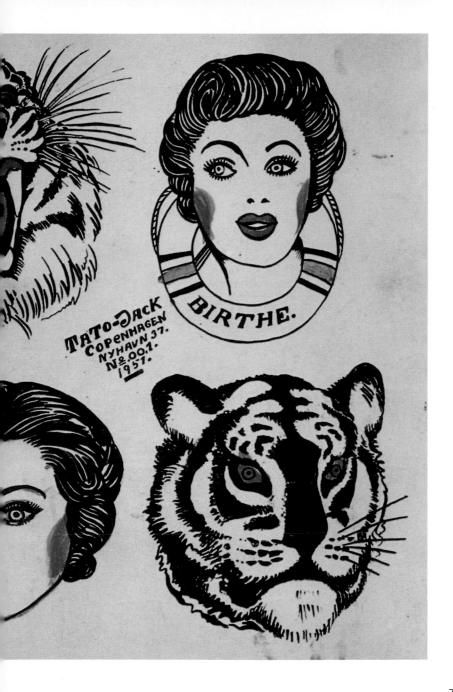

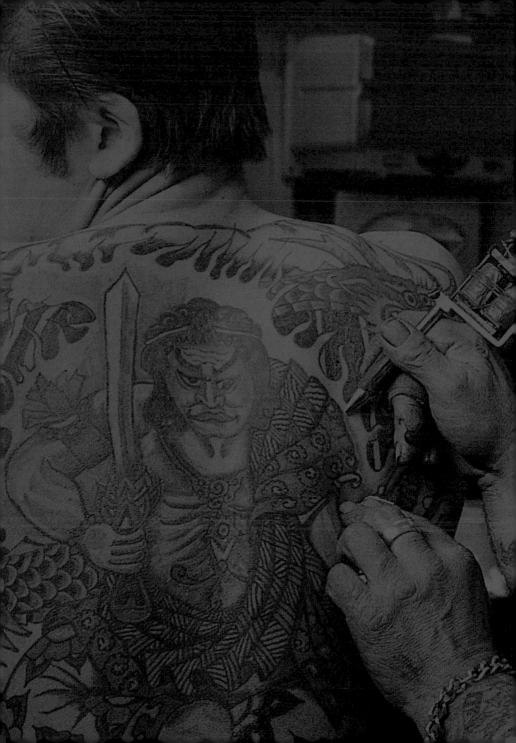

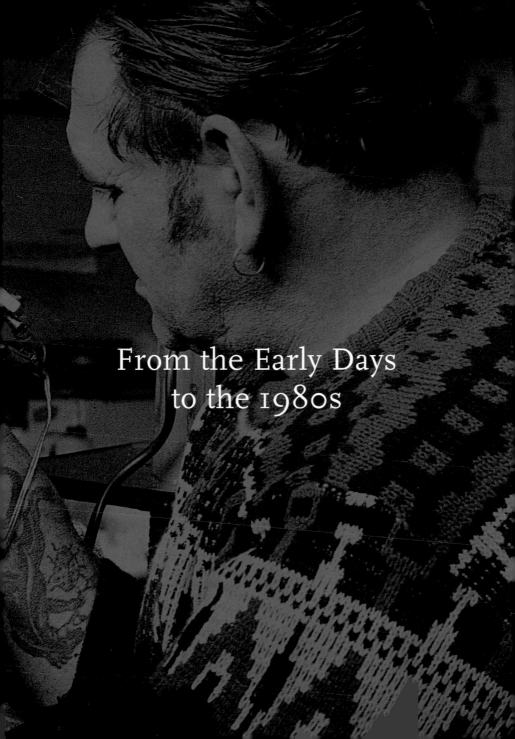

From the Early Days
to the 1980s

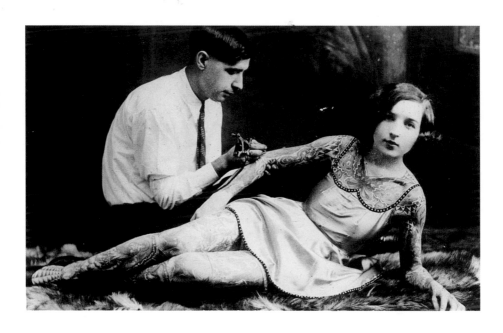

Deafy and Stelly Grossman, 1920s

Page 74 | 75: Les Skuse at Work, Bristol, Great Britain, 1960s

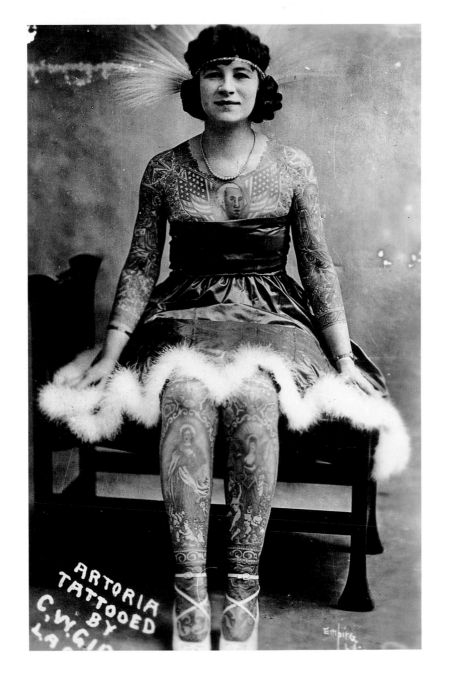

Artoria, Circus Lady, 1920s

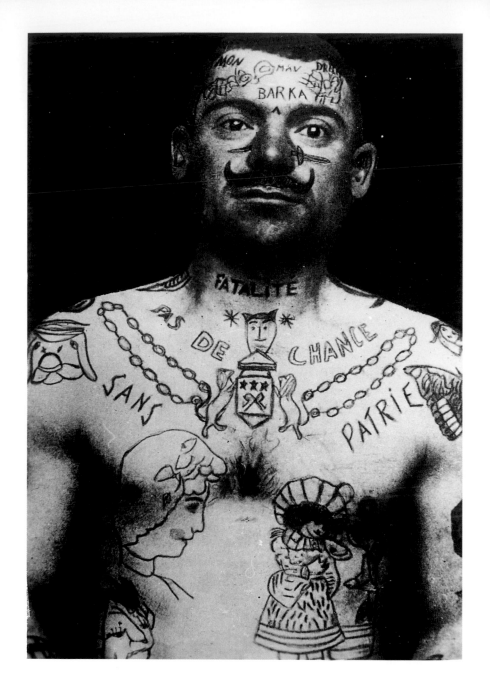

Artist Unknown, France, early 20th Century

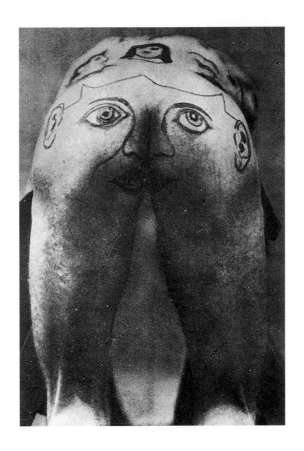

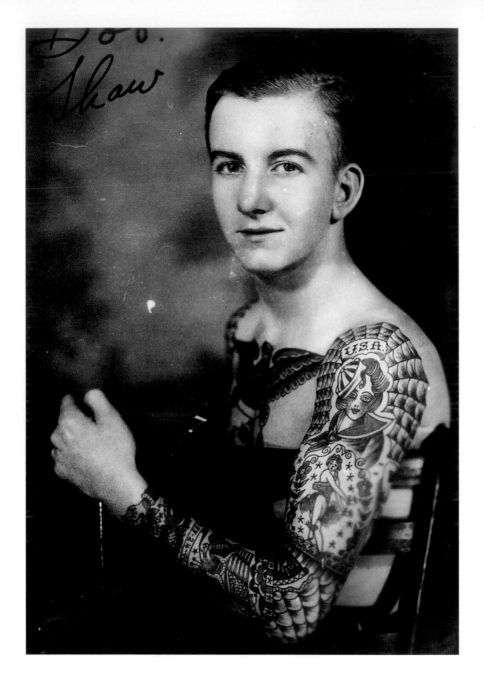

Bob Shaw Tattooed by Bert Grim, Los Angeles, USA (California), 1940s

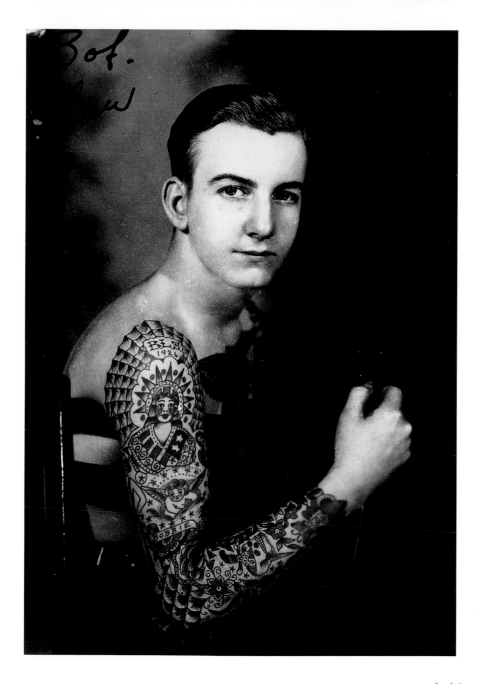

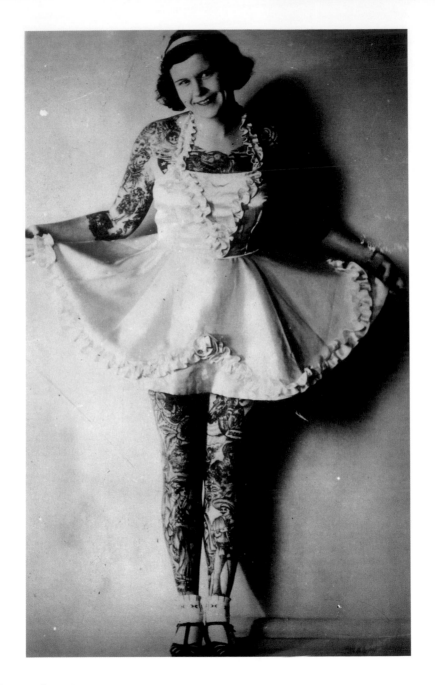

Circus Lady, USA, 1930s

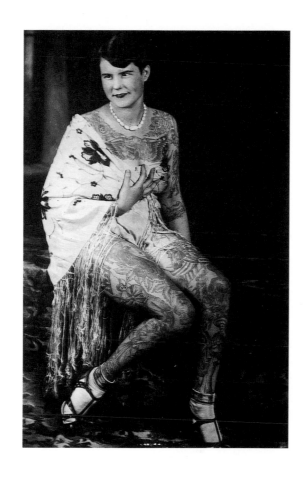

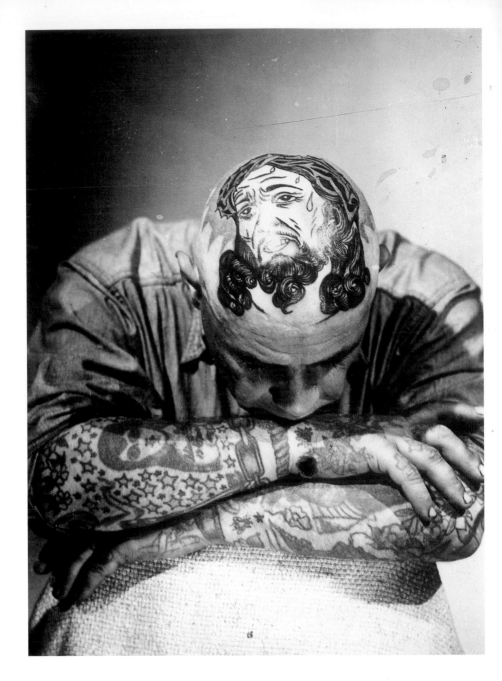

Tatts Thomas, Detroit, USA (Michigan), about 1930

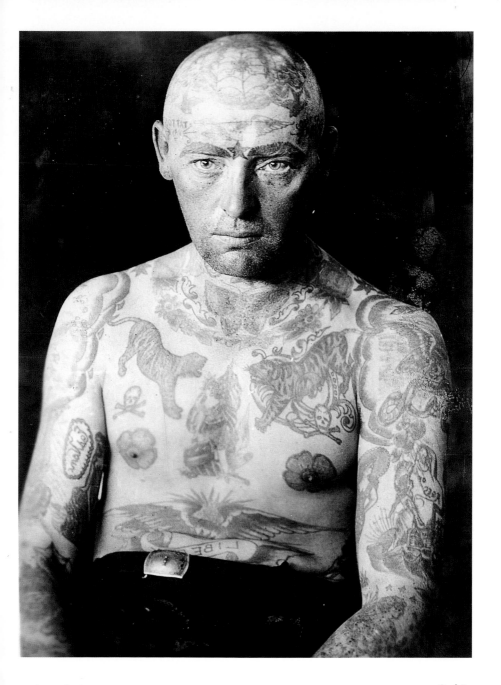

Artist Unknown, USA, 1930s

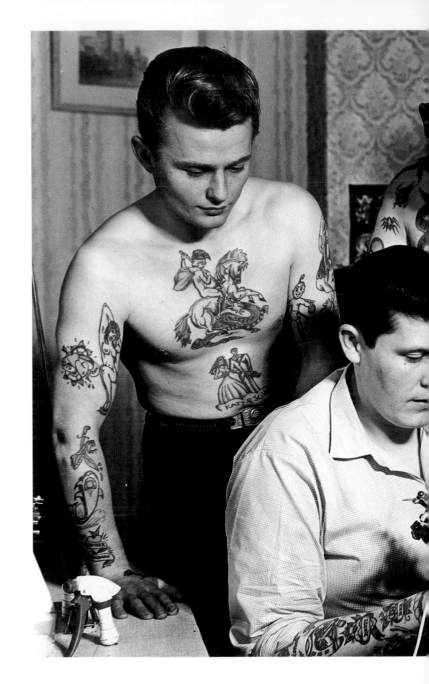

Ron Ackers at Work, Bristol, Great Britain, 1950s

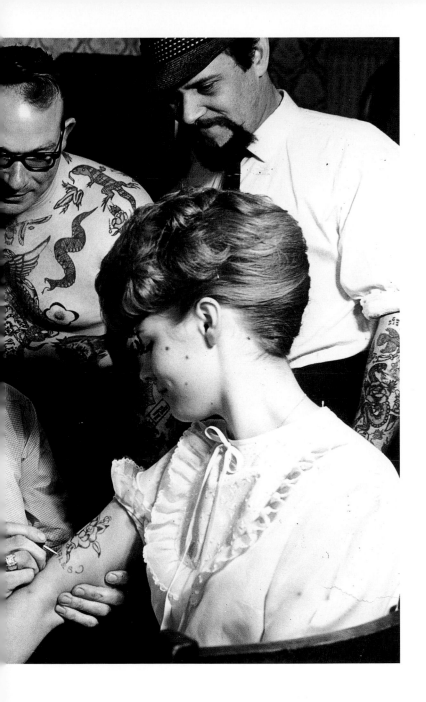

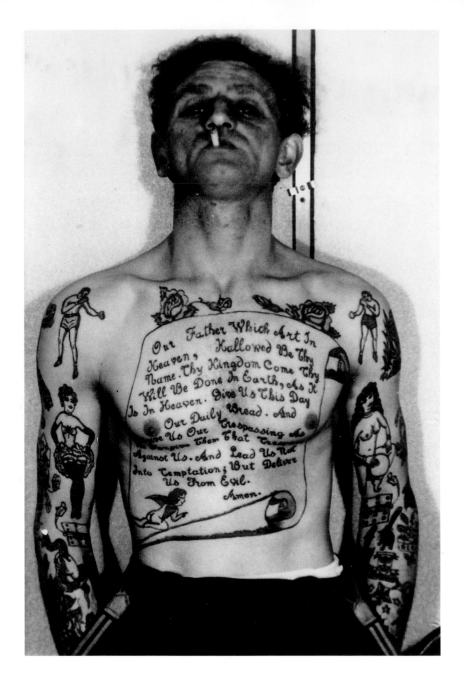

Member of the Bristol Tattooing Club, Great Britain, 1950s

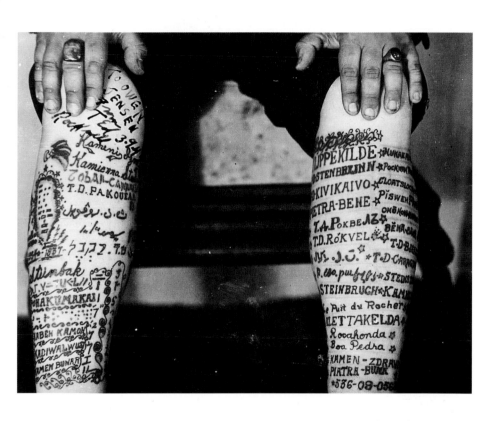

Artist Unknown, 1950s

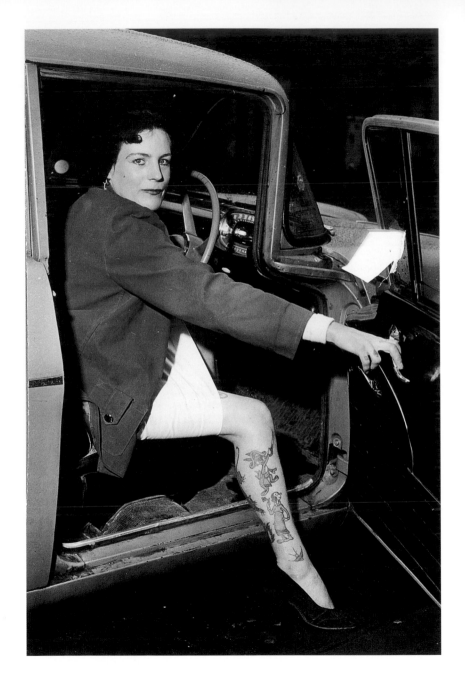

Members of the Bristol Tattooing Club, Great Britain, 1950s

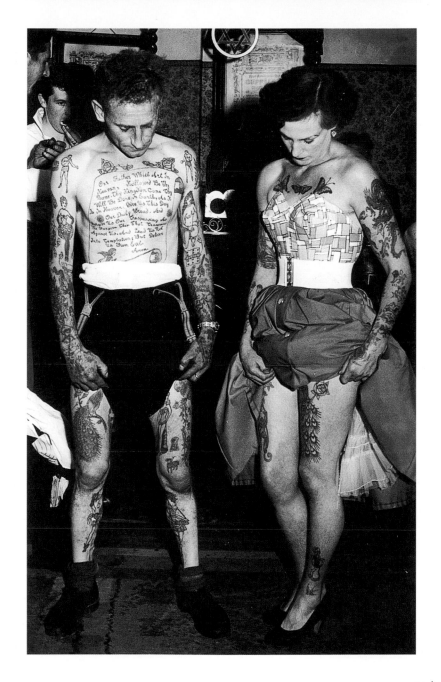

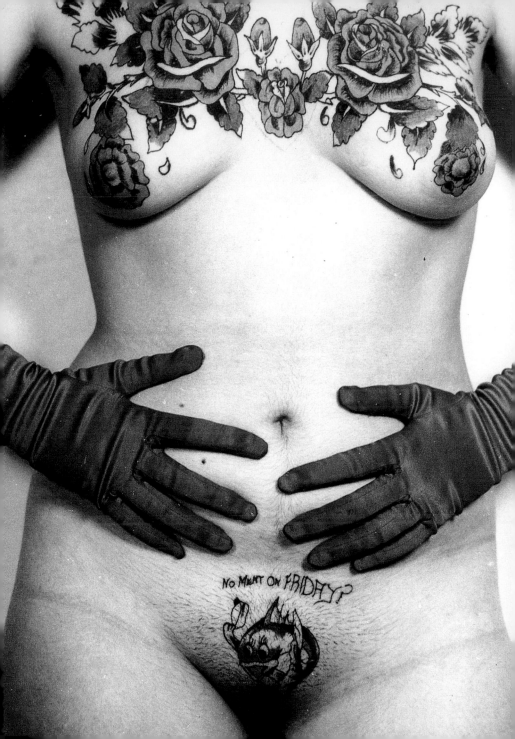

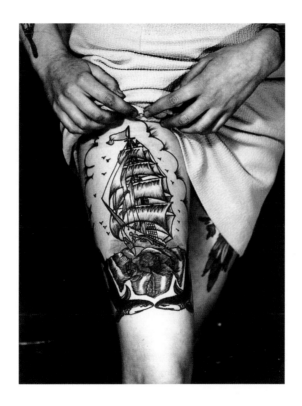

*Member of the Bristol Tattooing Club,
Great Britain, 1950s*

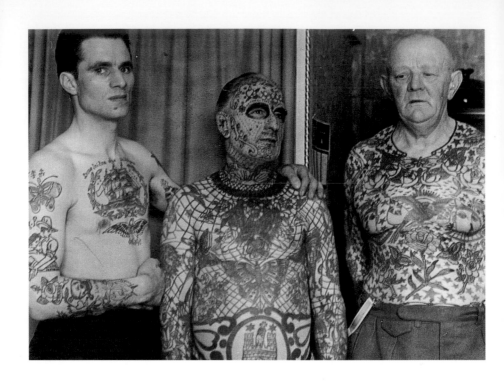

Herbert Hoffmann, Hamburg, Germany, 1960s

DISPLAY OTHER SIDE UP

Parking privileges may be revoked if vehicle owner is in violation of the University of Calgary Parking and Traffic Regulations.

Important note: Charges are for the use of parking space only. The University of Calgary is not responsible for and expressly disclaims liability for any loss or damage to vehicles, or contents, however caused. Owners are advised not to keep valuables in vehicles, and to ensure that all windows and doors are securely locked.

DISPLAY OTHER SIDE UP

G.S.T. Registration No. R108102864

UofC
LOT 10

10/09/04

ONE ENTRY

$ 2.75 13:33
23016 244 232090

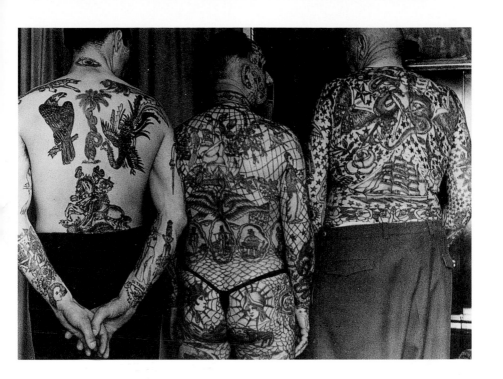

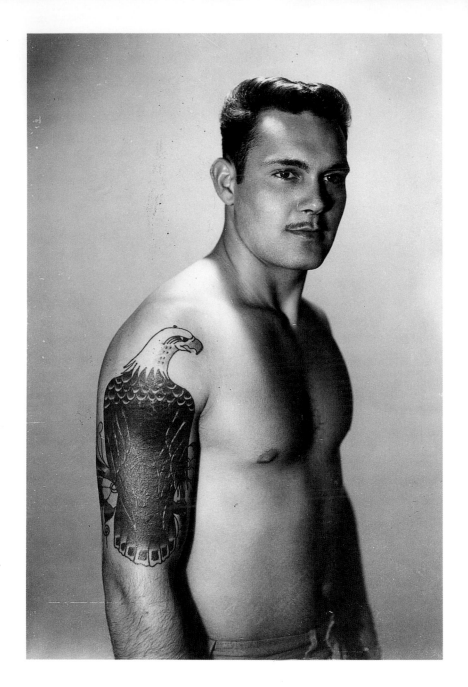

Artist Unknown, 1960s

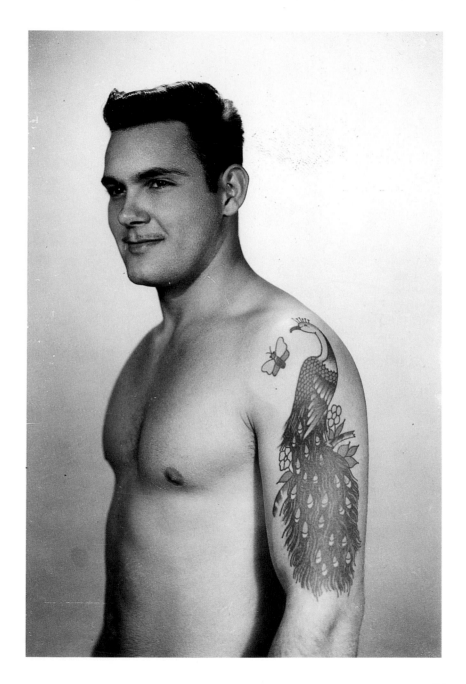

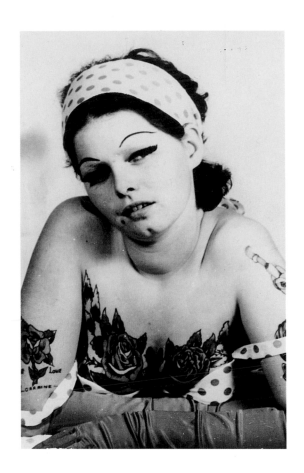

Artist Unknown, Australia, 1960s

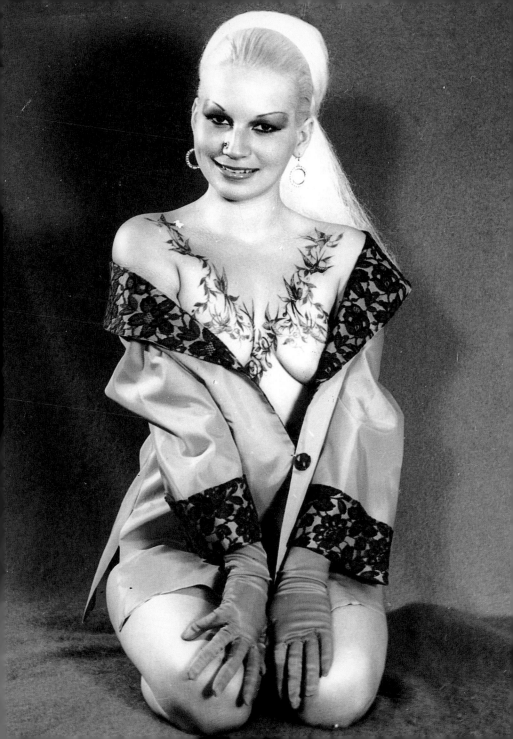

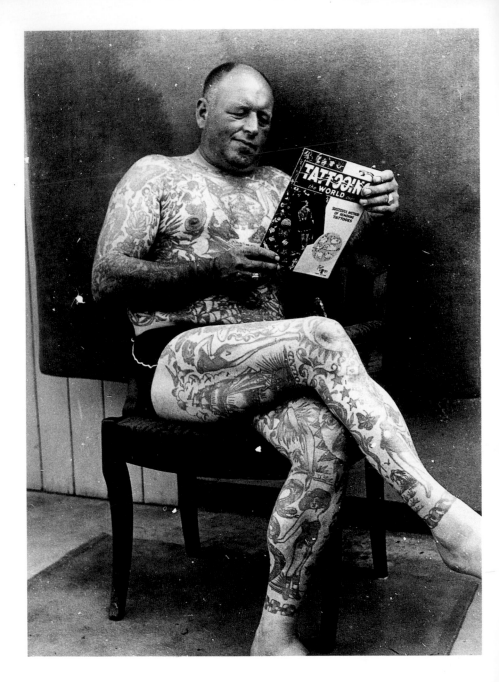

Albert Cornelison, The Netherlands, 1950s

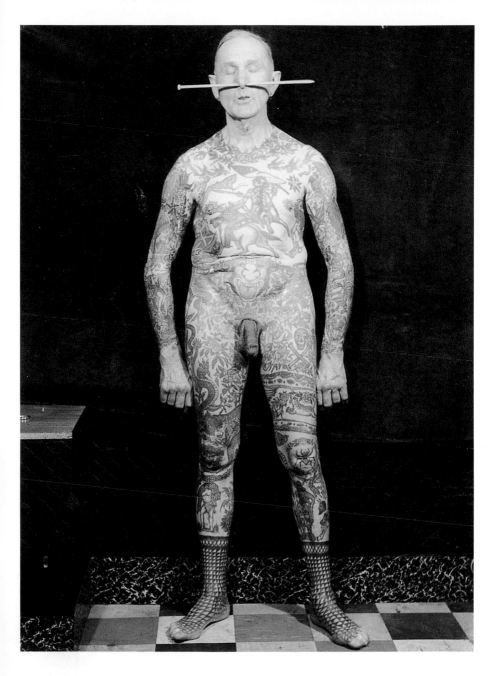

Les Skuse, Bristol, Great Britain, 1960s

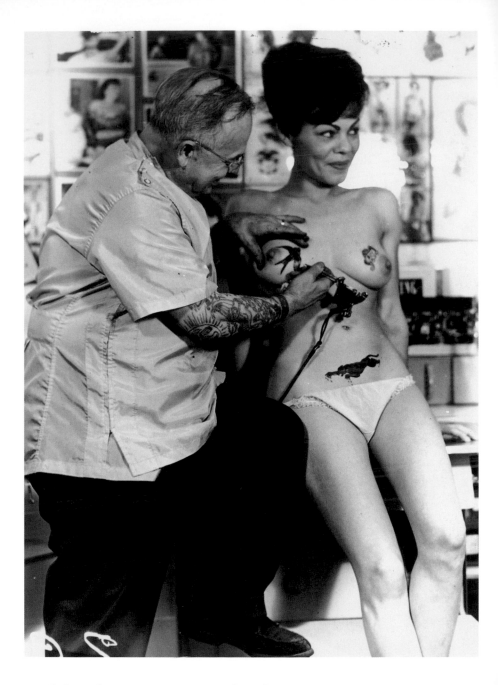

Doc Forbes and Bunny, Vancouver, Canada, 1960s

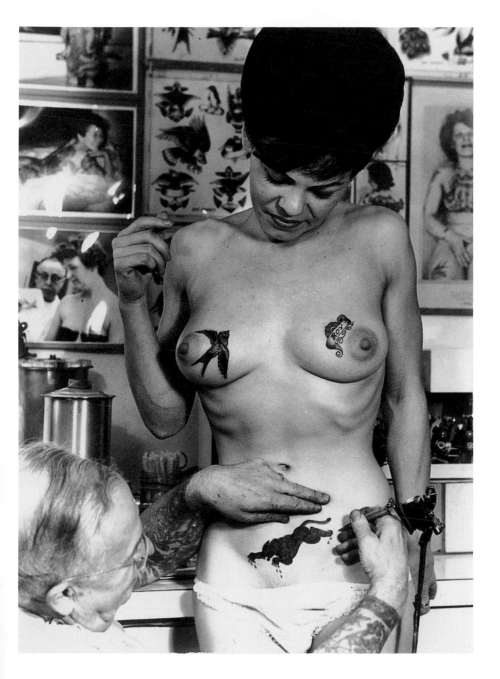

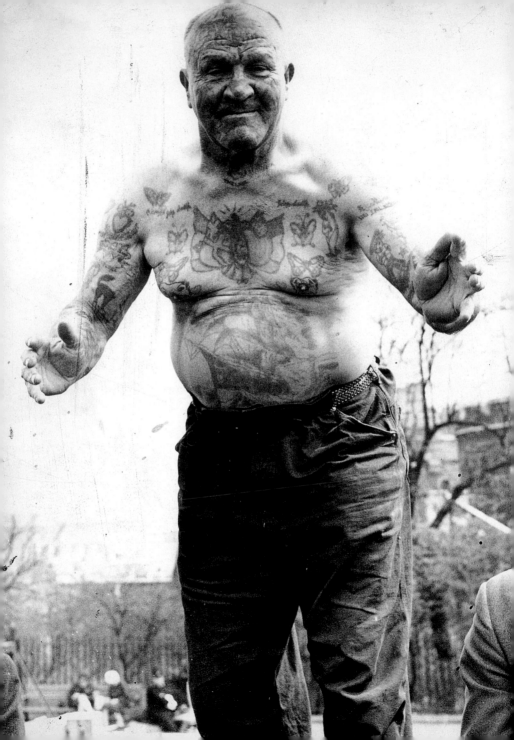

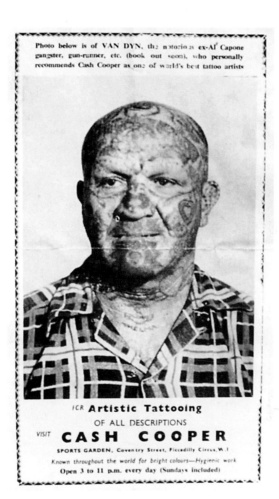

Photo below is of VAN DYN, the notorious ex-Al Capone
gangster, gun-runner, etc. (book out soon), who personally
recommends Cash Cooper as one of world's best tattoo artists

ICR Artistic Tattooing
OF ALL DESCRIPTIONS
VISIT **CASH COOPER**
SPORTS GARDEN, Coventry Street, Piccadilly Circus, W.1
Known throughout the world for bright colours—Hygienic work
Open 3 to 11 p.m. every day (Sundays included)

Van Dyn Tattooed by Cash Cooper, London, Great Britain, 1960s

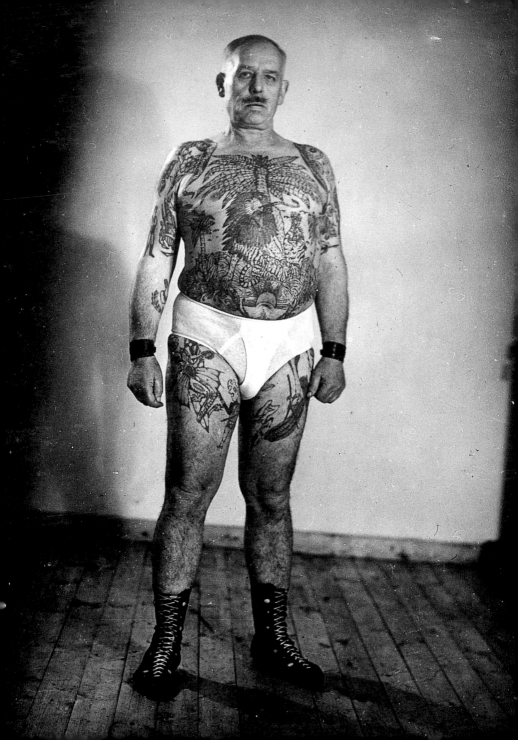

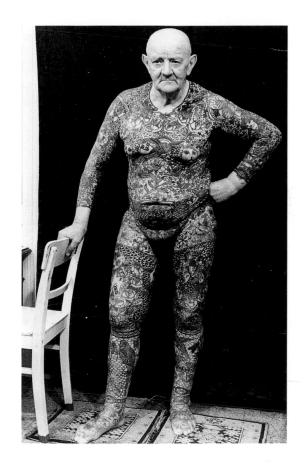

Herbert Hoffmann, Hamburg, Germany, 1960s

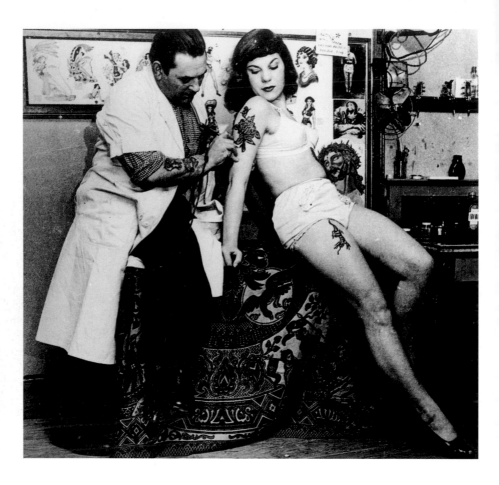

Les Skuse at Work, Bristol, Great Britain, 1960s

Cindy Ray in her Studio, Ivanhoe, Australia, 1960s

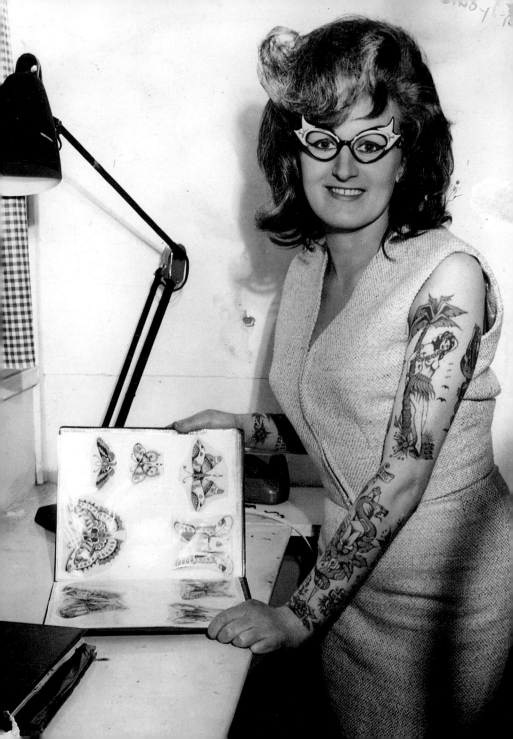

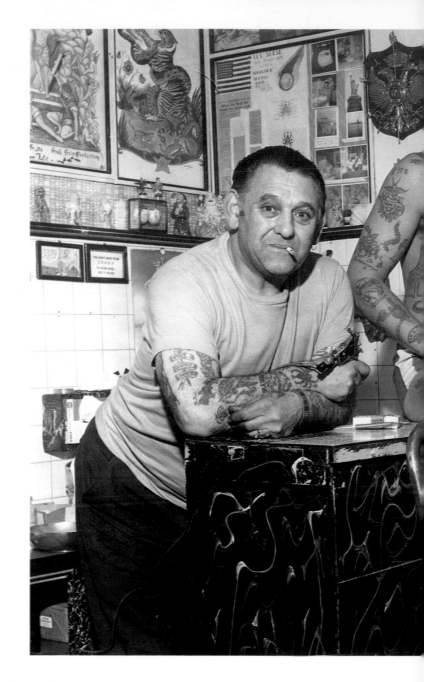

Les Skuse in his Studio, Bristol, Great Britain, 1960s

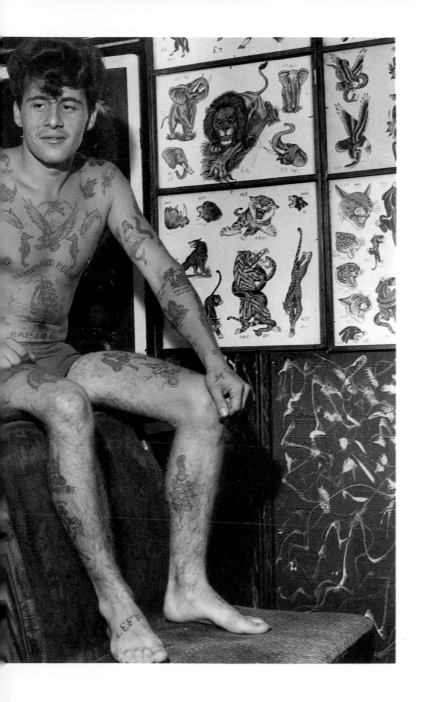

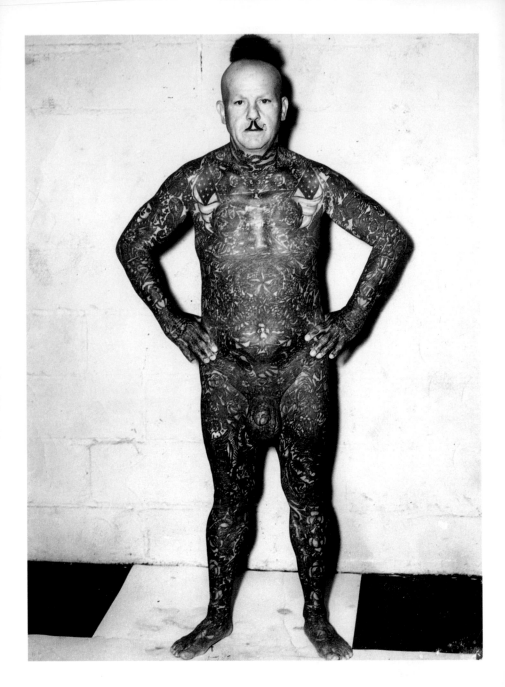

Artist Unknown, 1970s

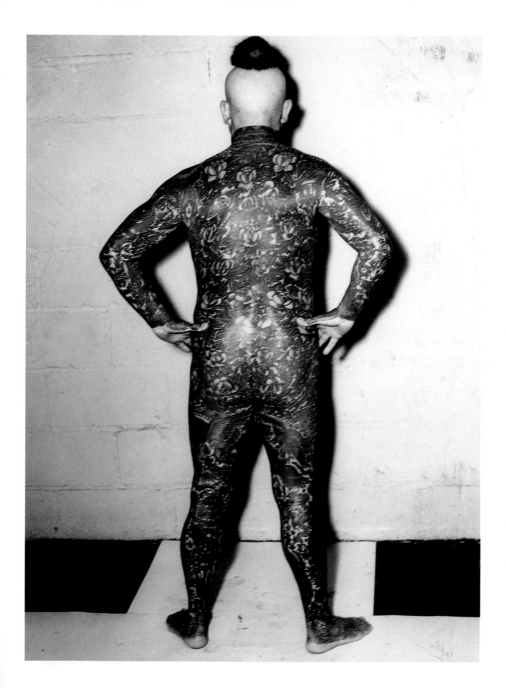

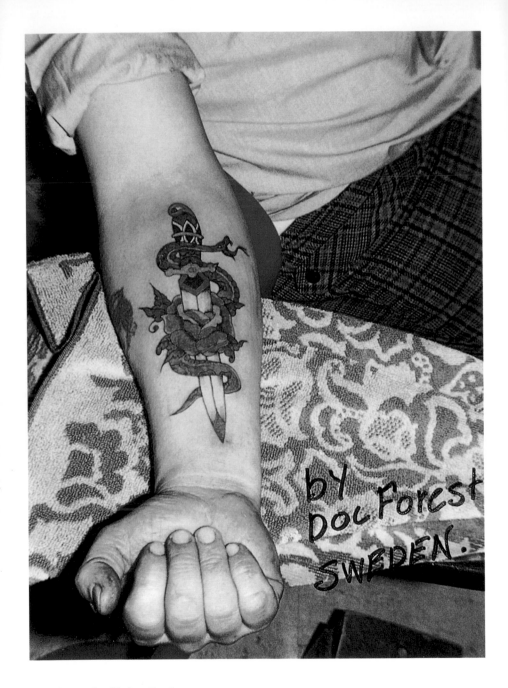

Doc Forest, Stockholm, Sweden, 1970s

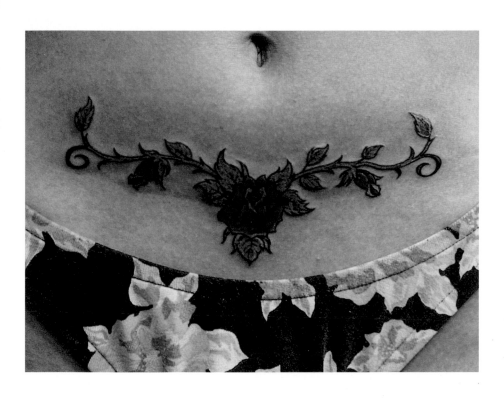

Martin Robson, San Diego, USA (California), 1970s

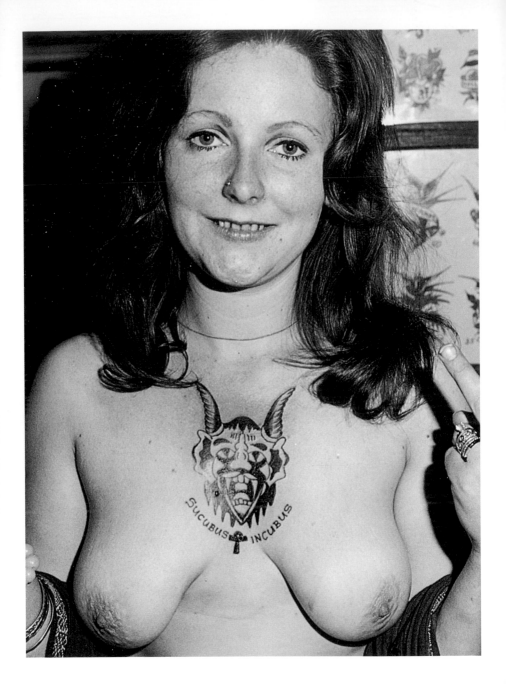

Tattoo Peter, Amsterdam, The Netherlands, 1970s

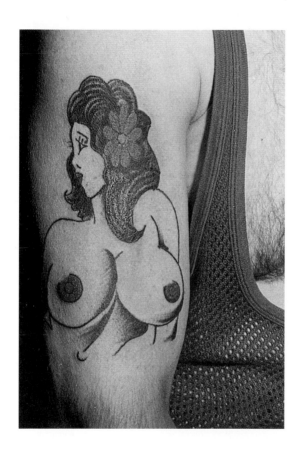

Artist Unknown, 1970s

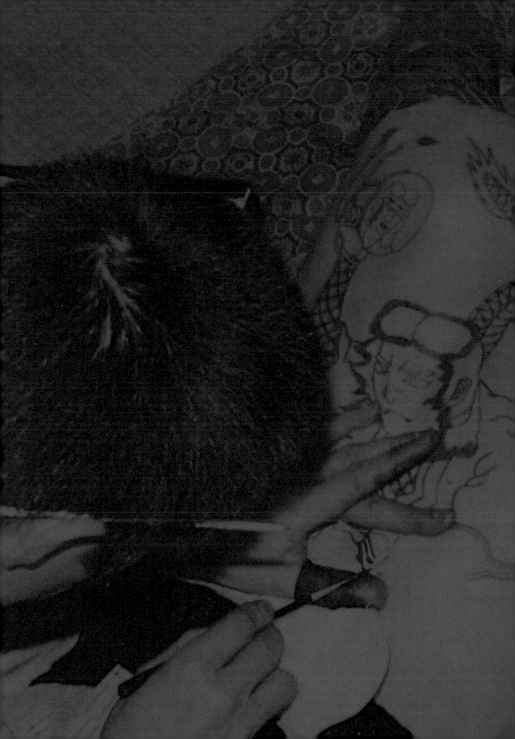

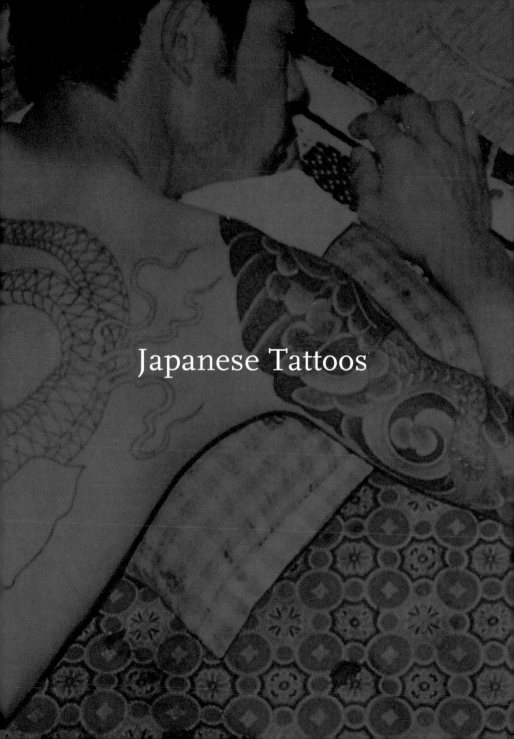

Japanese Tattoos

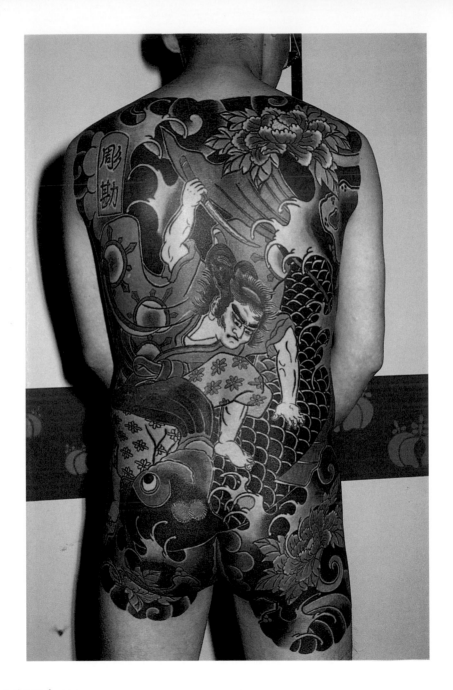

Artist Unknown

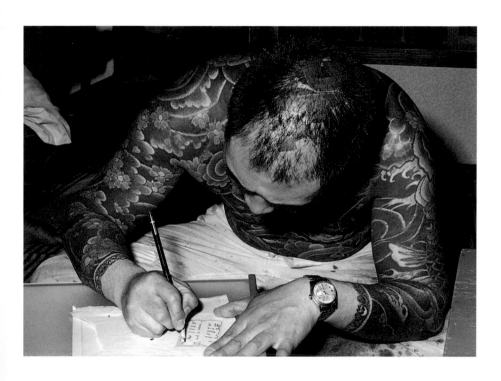

Mitsuaki Ohwada at Work, Yokohama

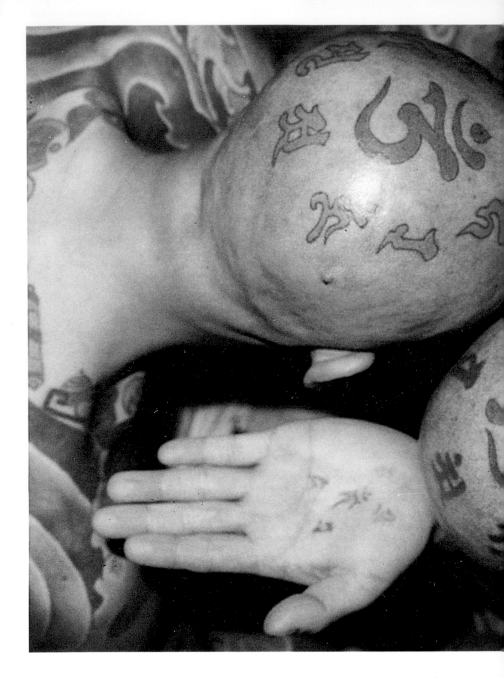

Horiyoshi III, Yokohama

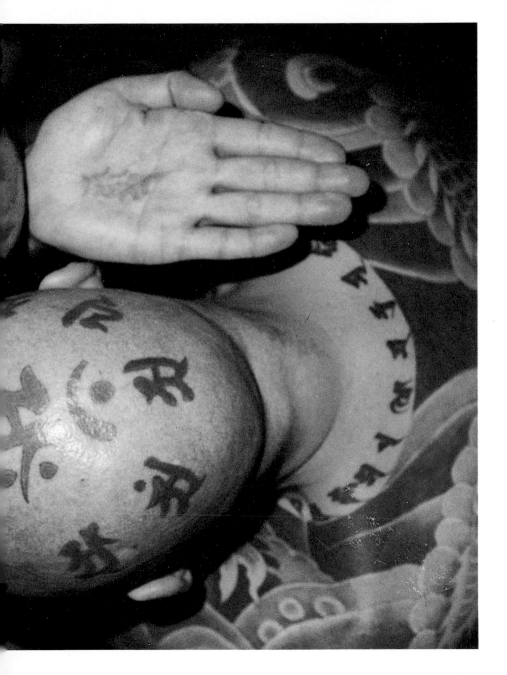

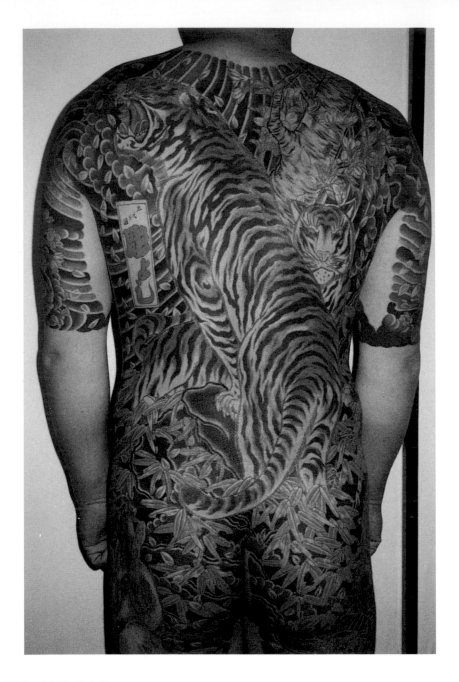

Horiyoshi III, Yokohama

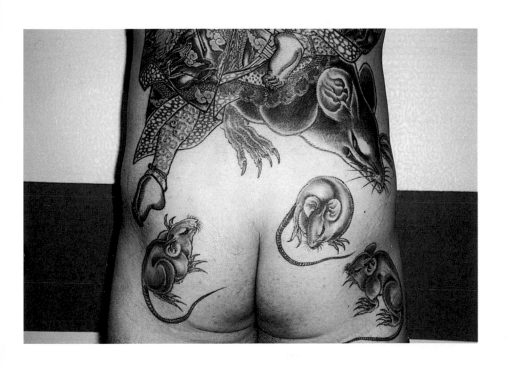

Mitsuaki Ohwada in his Studio, Yokohama

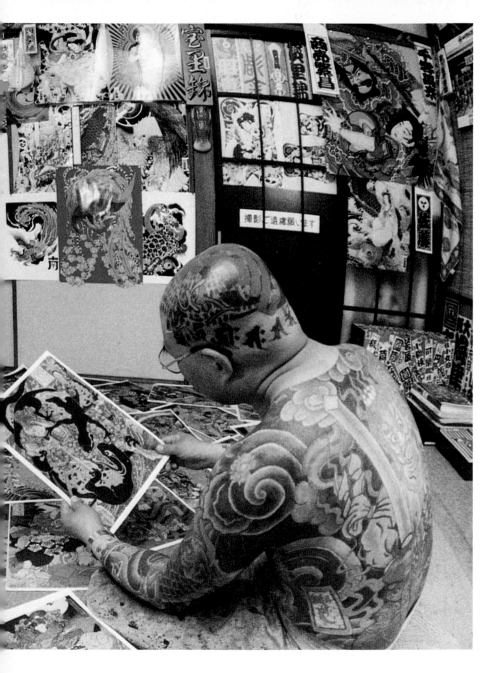

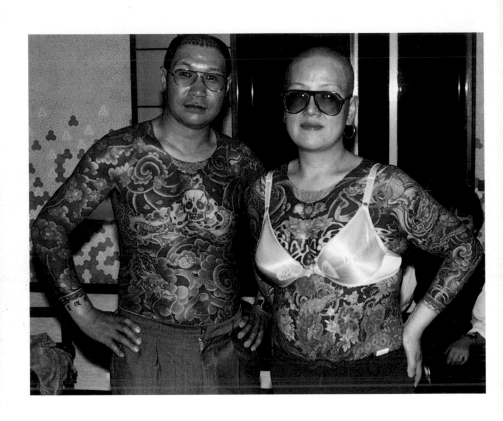

Mitsuaki Ohwada and his Wife, Yokohama

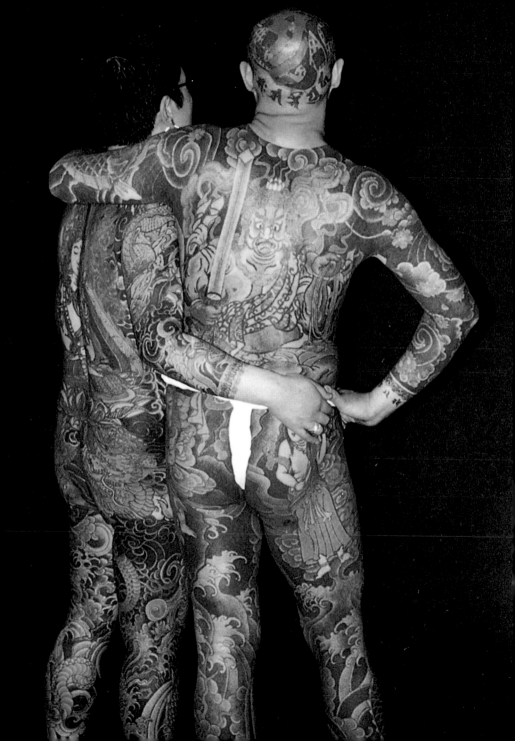

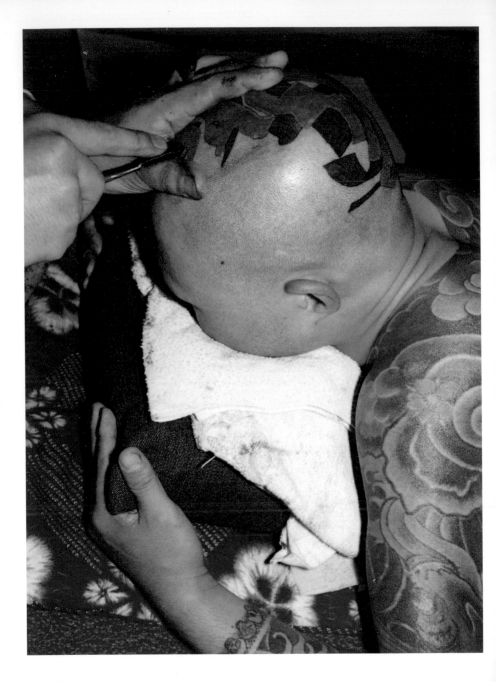

Mitsuaki Ohwada at Work, Yokohama

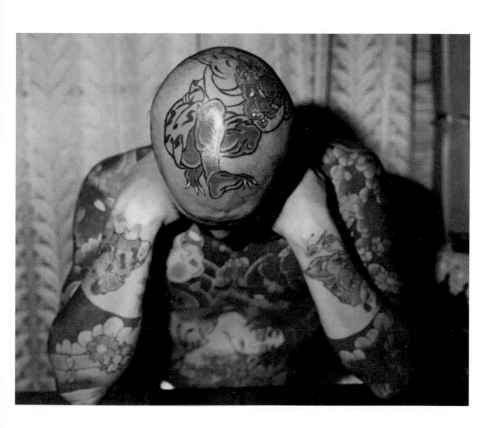

Artist Unknown

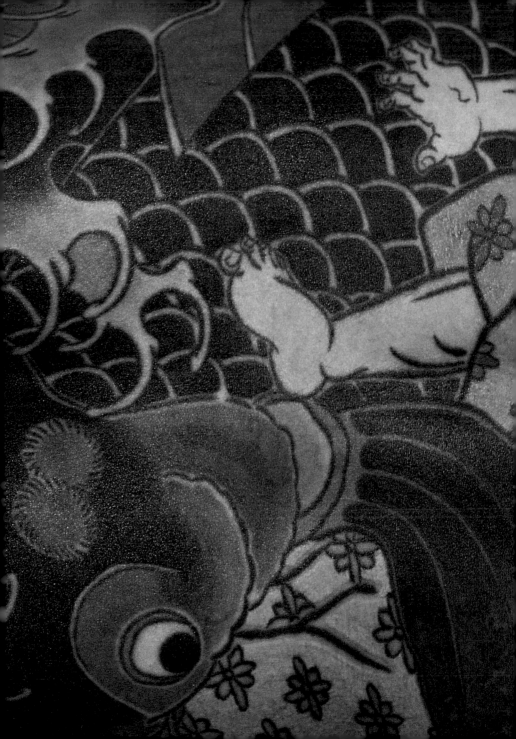

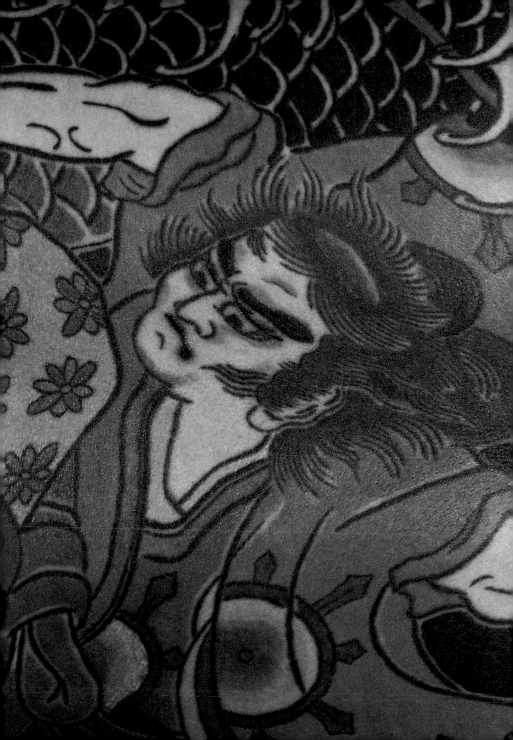

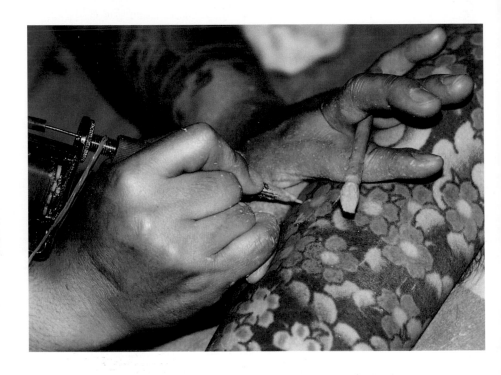

Tattooing Process

Mitsuaki Ohwada, Yokohama

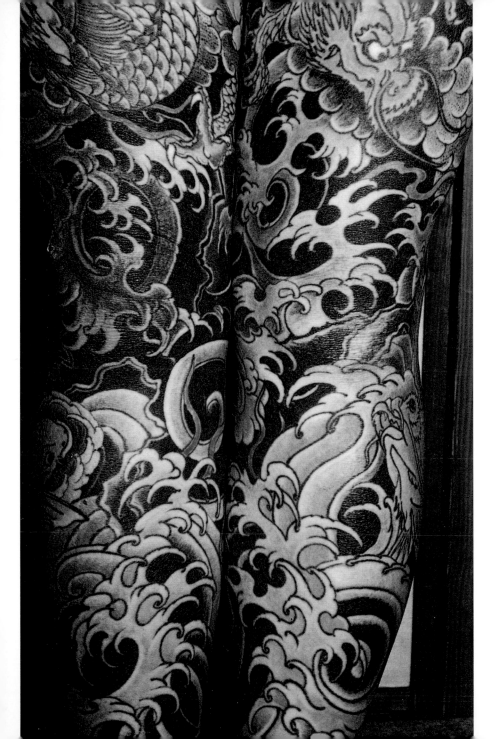

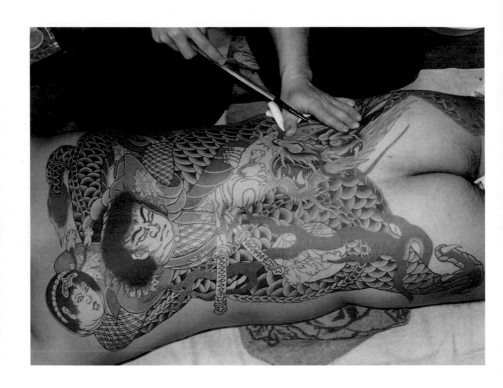

Horiwaka, Tokyo

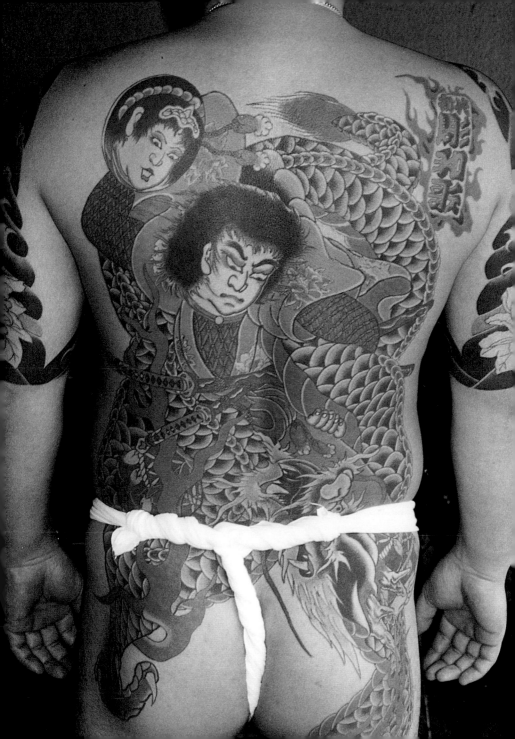

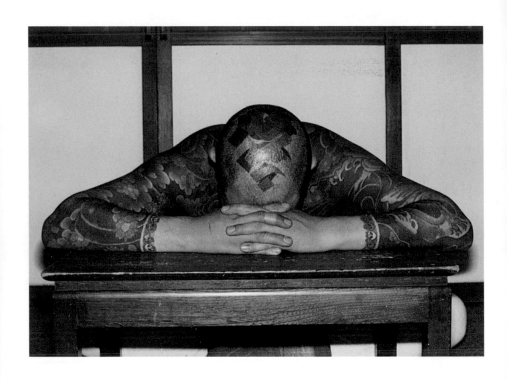

Mitsuaki Ohwada, Yokohama

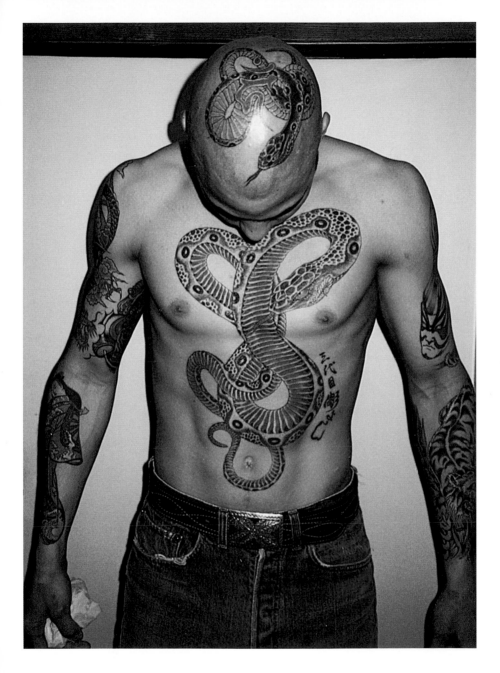

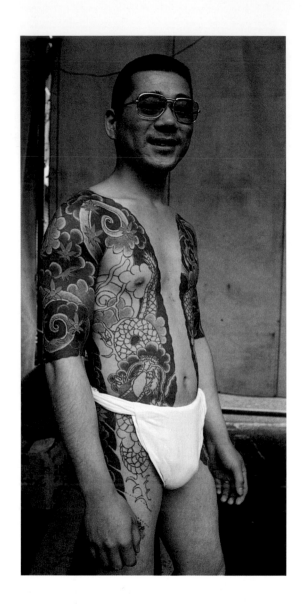

Artist Unknown

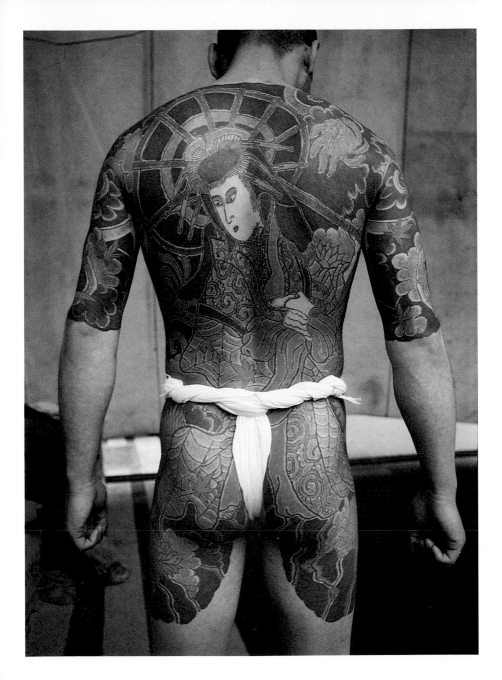

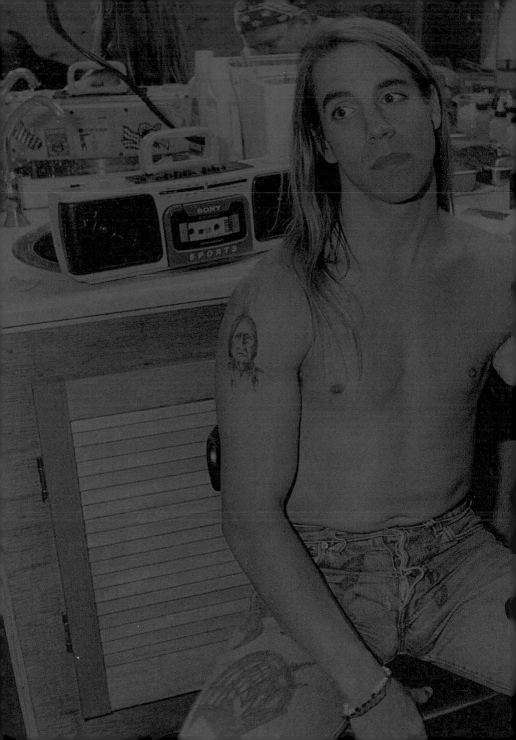

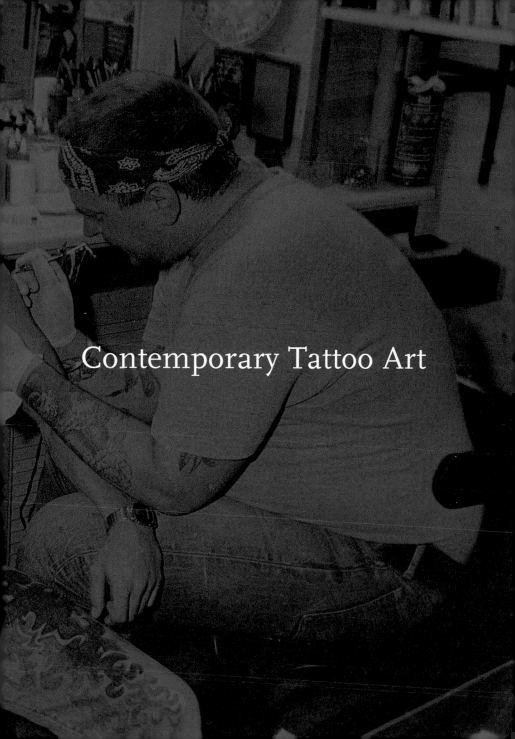

Contemporary Tattoo Art

Dave Lum, Salem, USA (Oregon)

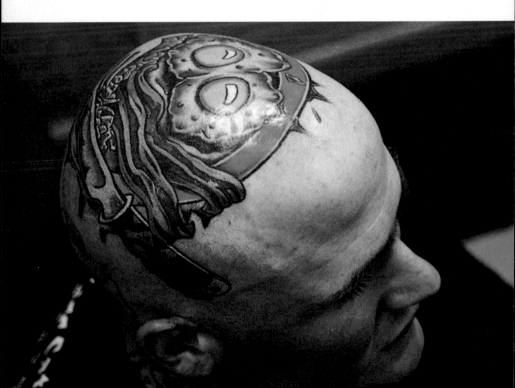

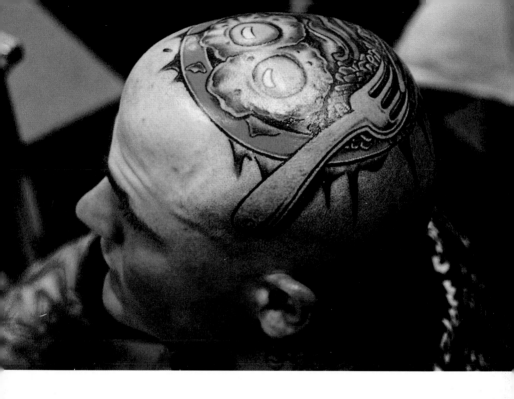

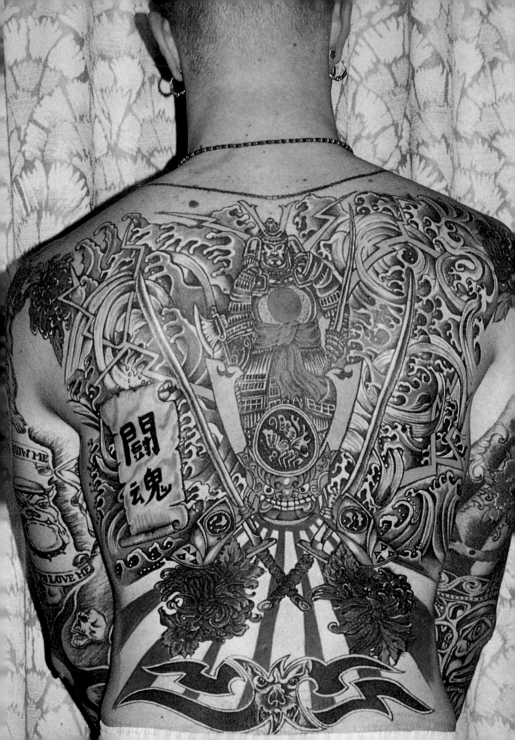

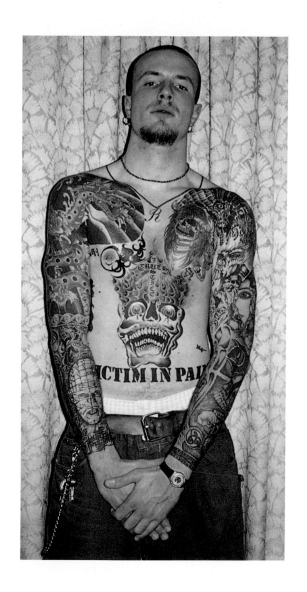

Tattoo Guus, Maastricht, The Netherlands

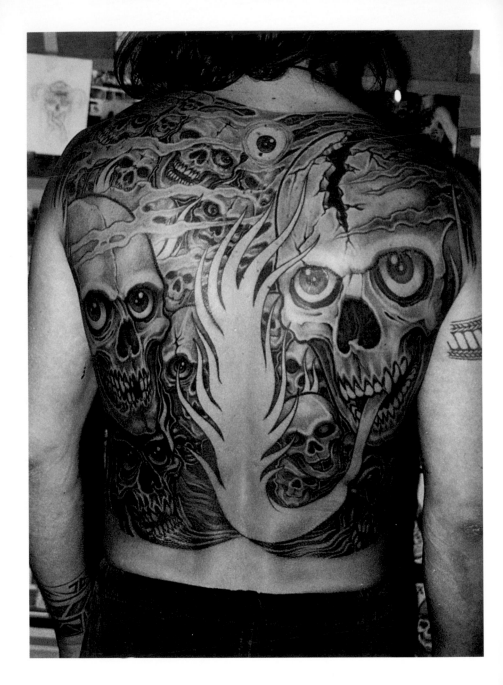

Filip Leu, Lausanne, Switzerland

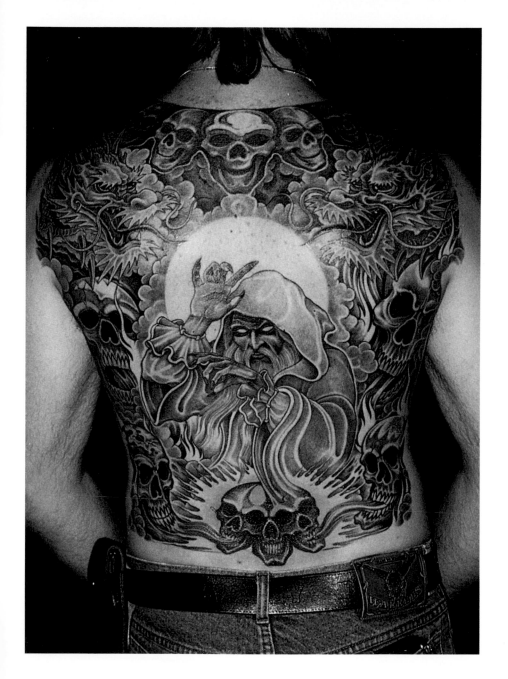

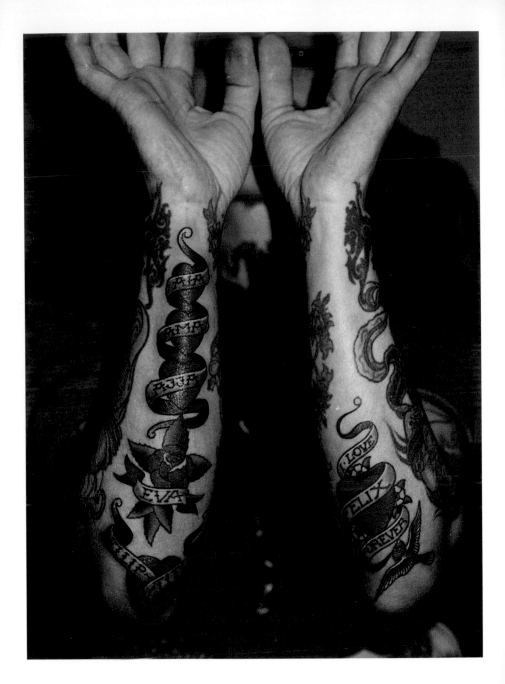

Felix Leu, Lausanne, Switzerland

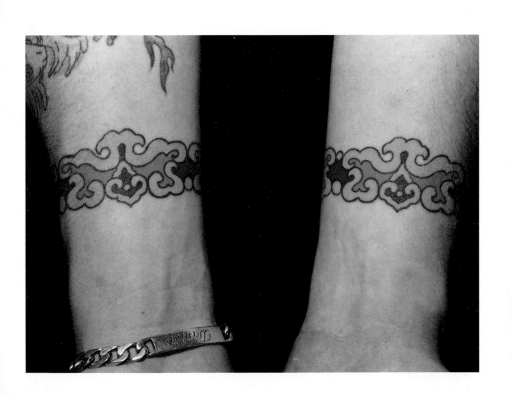

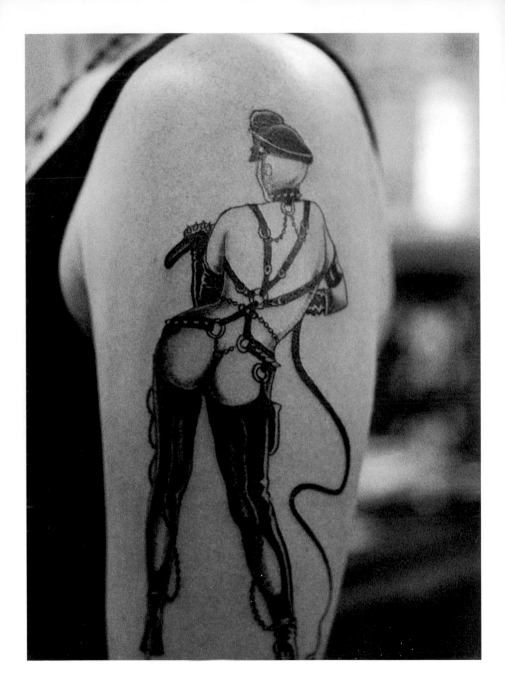

Nala Smith, San Francisco, USA (California)

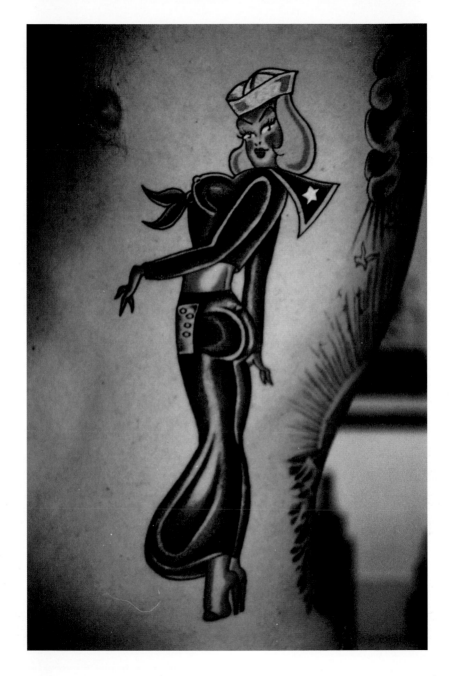

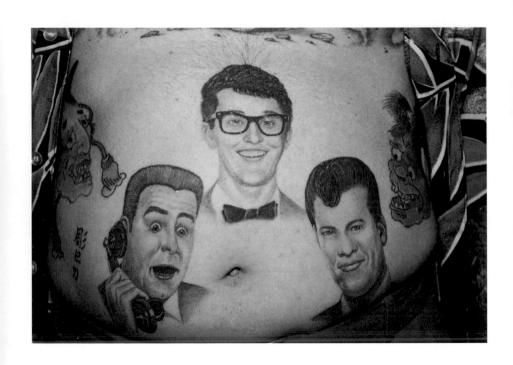

Jack Rudy, Anaheim, USA (California)

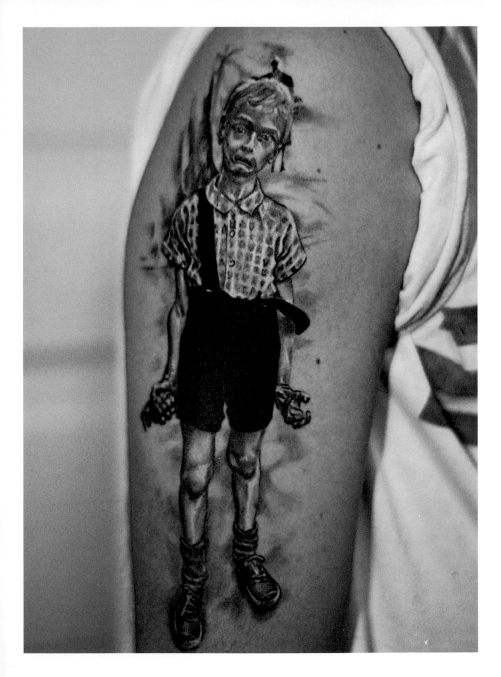

Marcus Pacheco, San Francisco, USA (California)

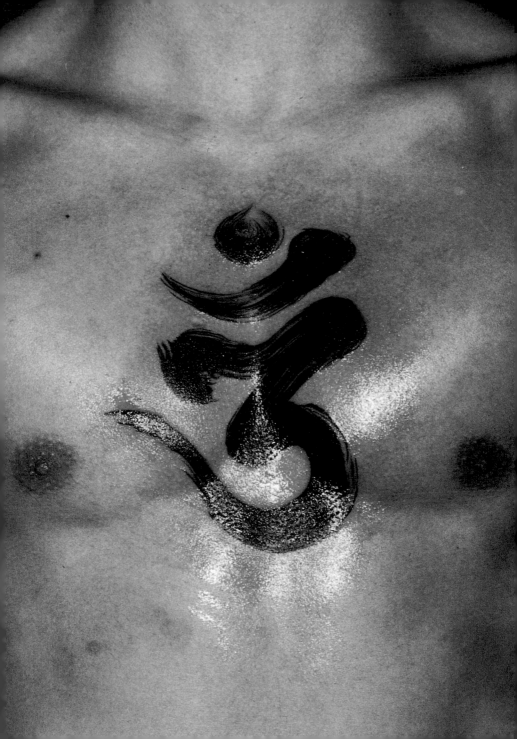

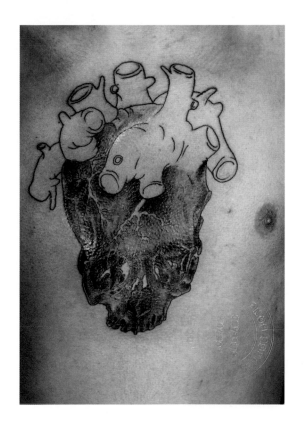

George Bone, London, Great Britain

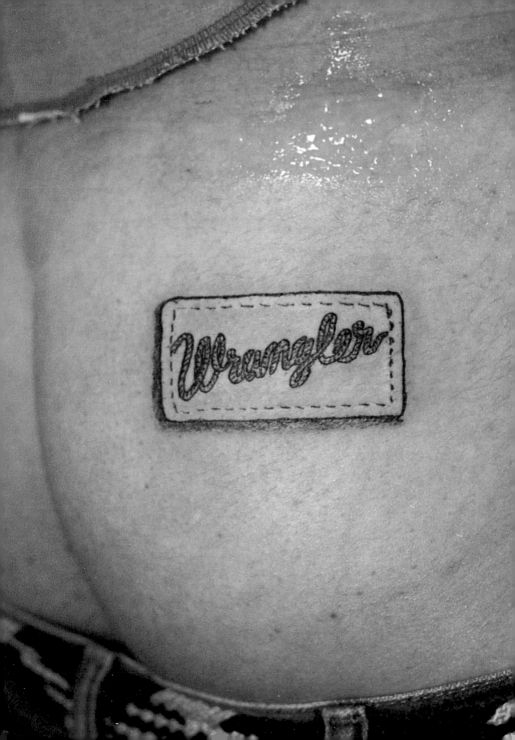

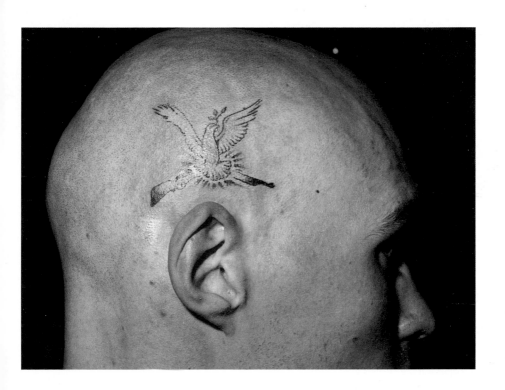

Artist Unknown

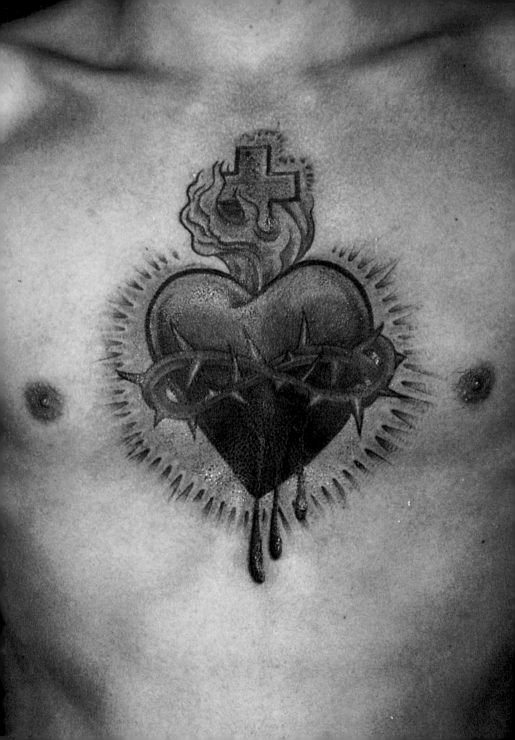

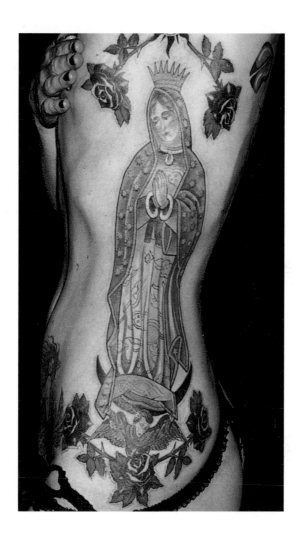

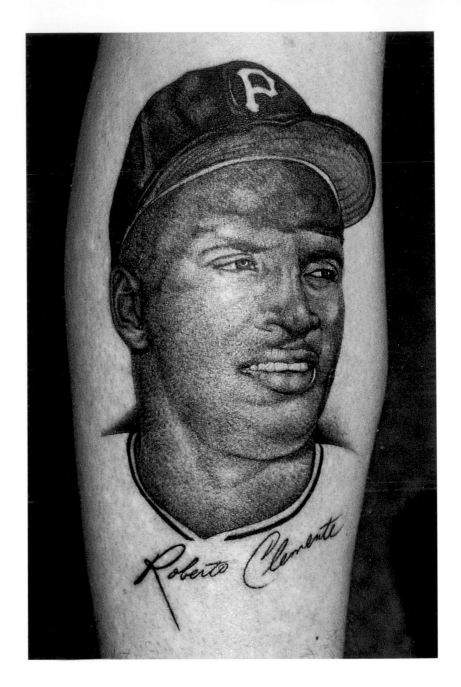

Brian Everett, Albuquerque, USA (New Mexico)

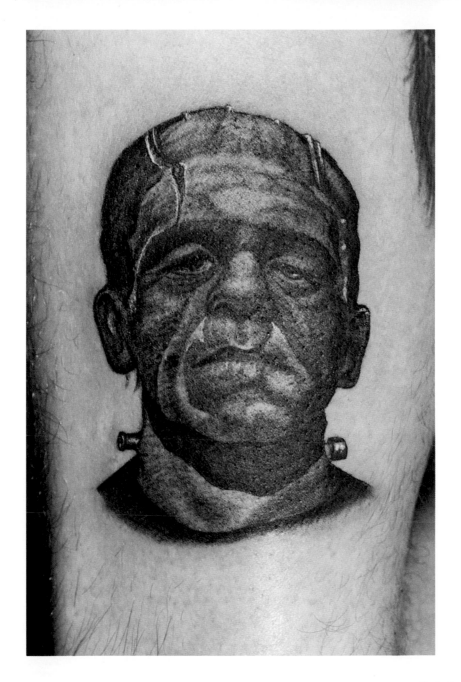

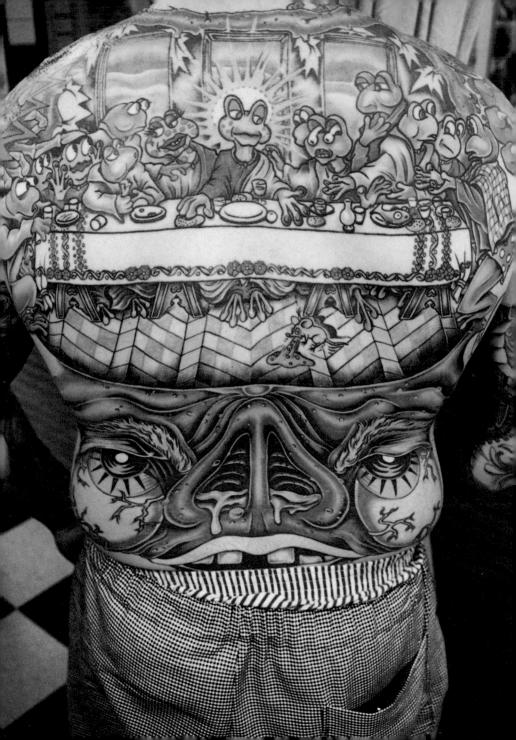

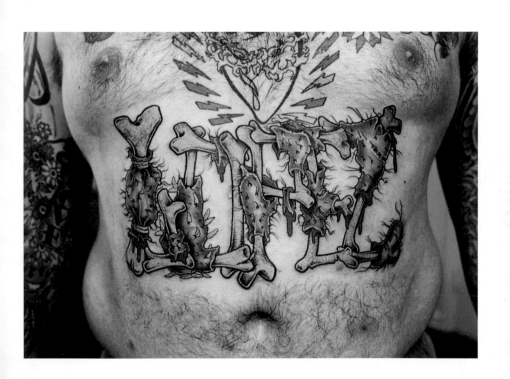

Dave Lum, Salem, USA (Oregon)

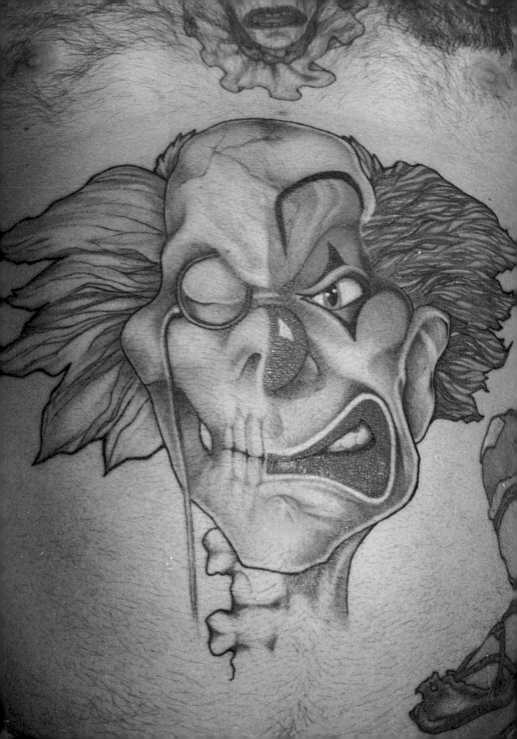

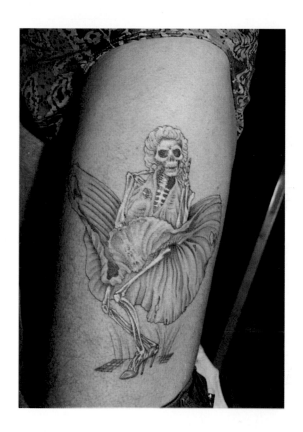

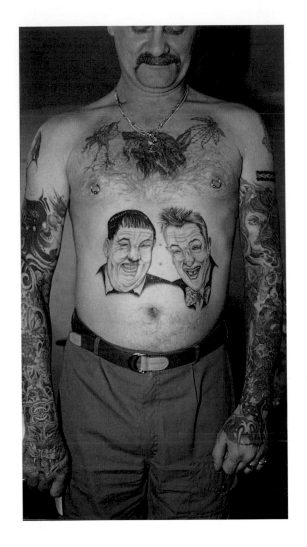

Ronald Bonkerk, Zaandam, The Netherlands

Jack Rudy, Anaheim, USA (California)

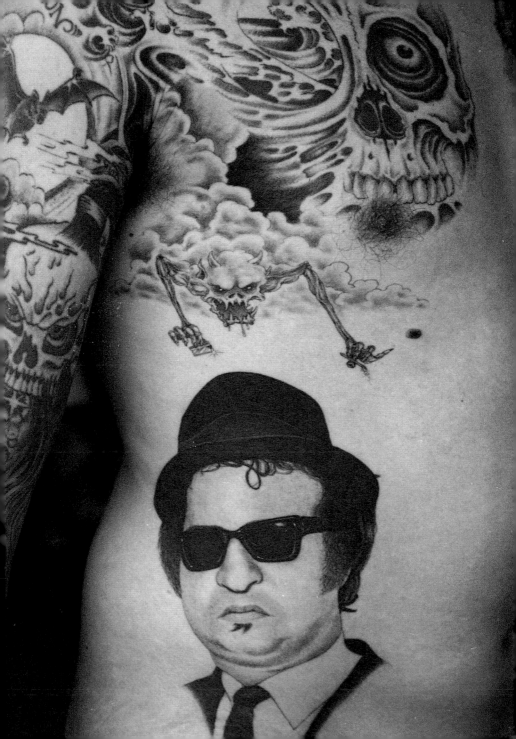

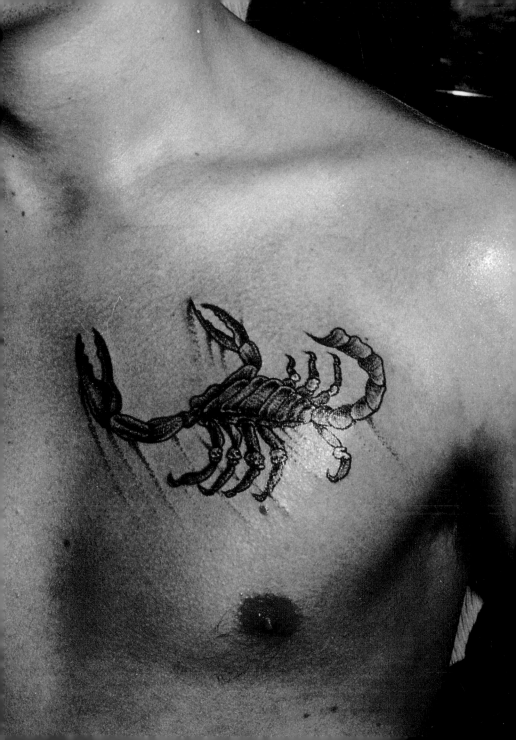

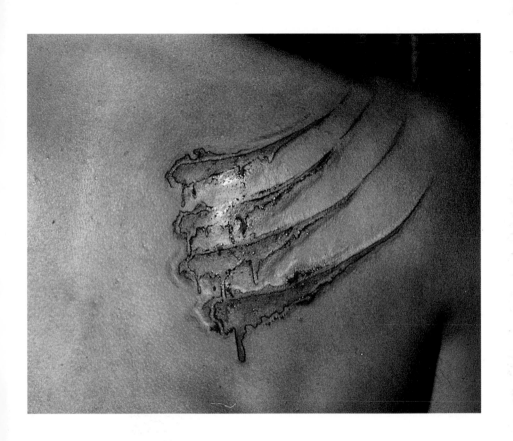

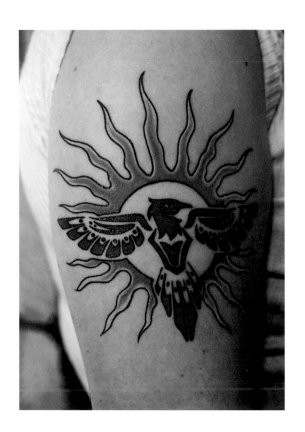

Dave Lum, Salem, USA (Oregon)

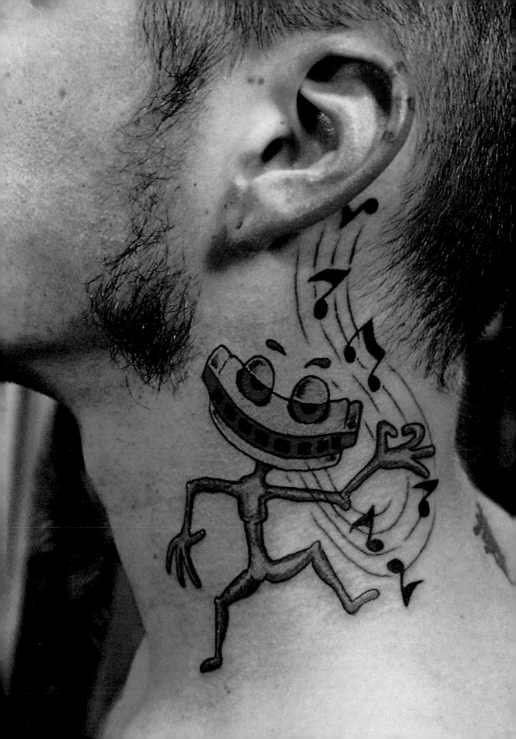

Greg Ordi, Eindhoven, The Netherlands

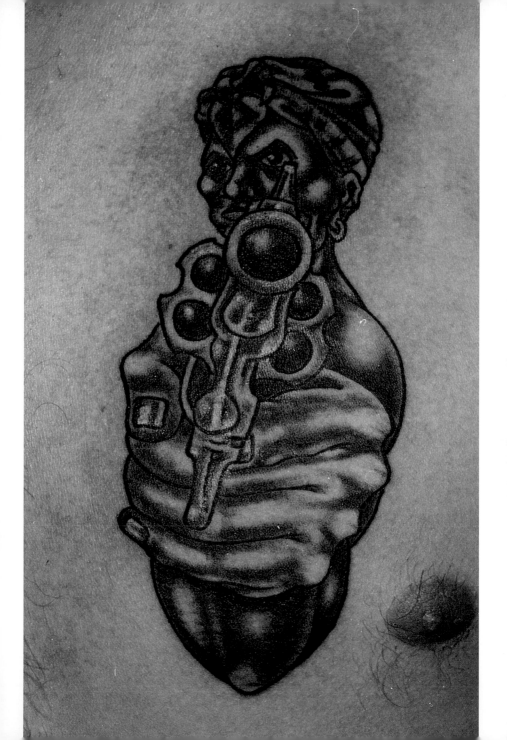

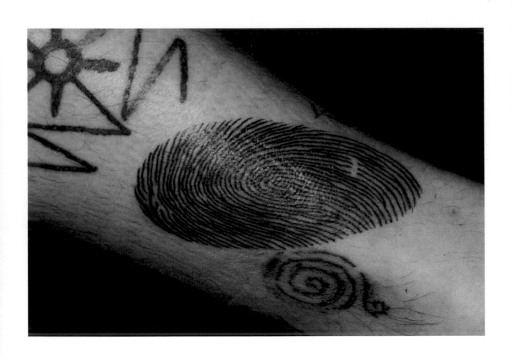

Luke Atkinson, Stuttgart, Germany

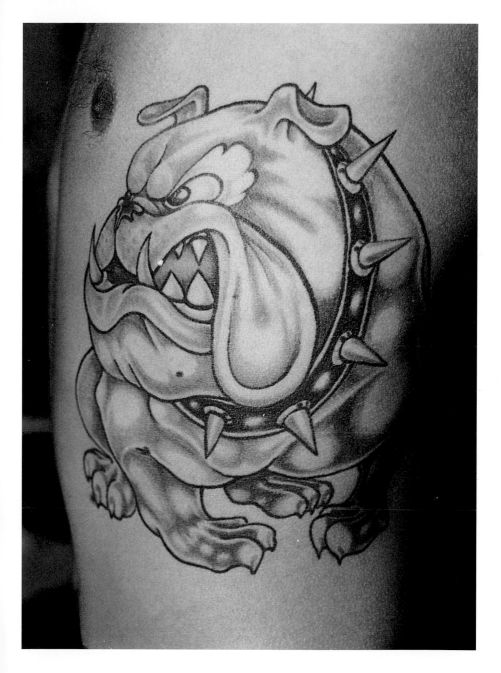

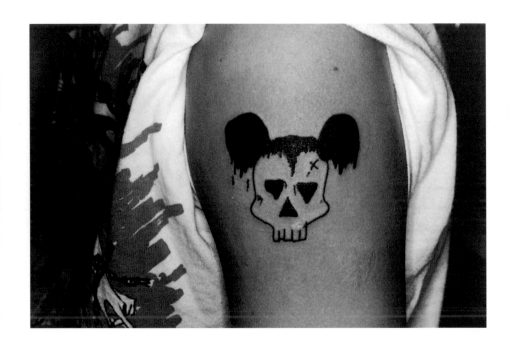

Artist Unknown

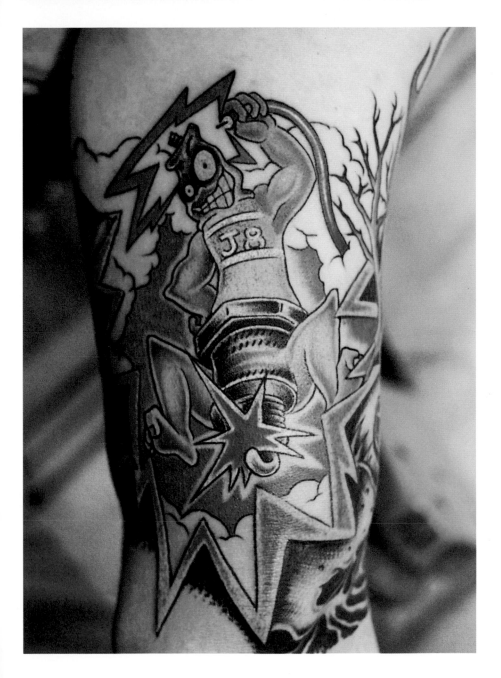

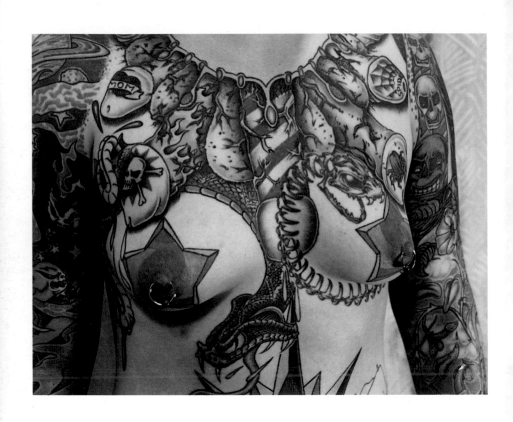

Dave Lum, Salem, USA (Oregon)

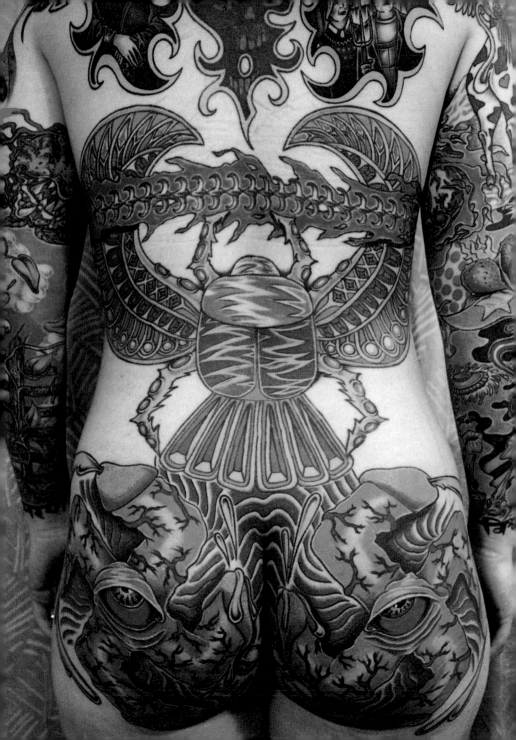

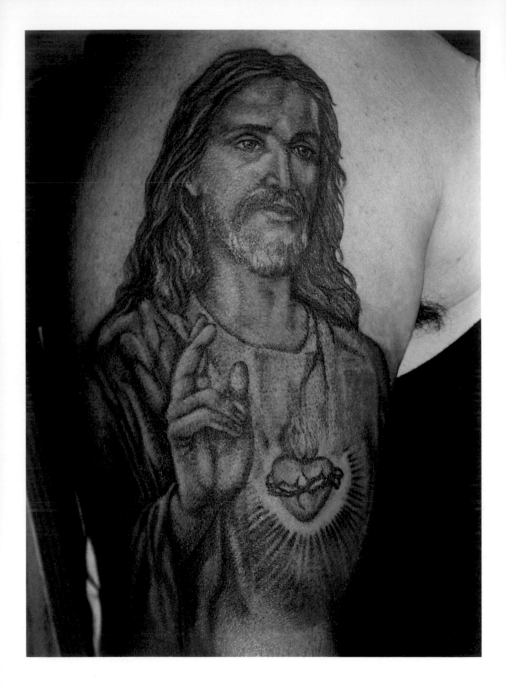

Brian Everett, Albuquerque, USA (New Mexico)

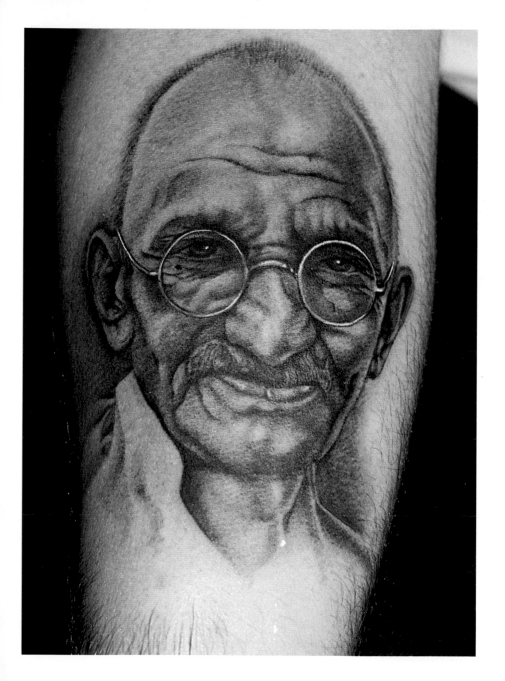

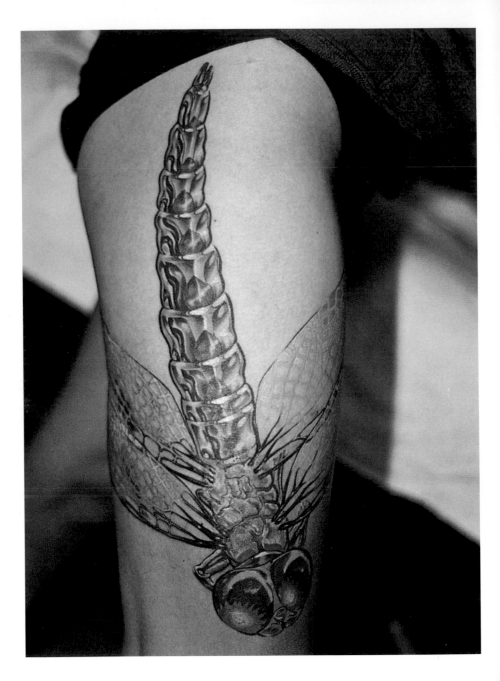

Marcus Pacheco, San Francisco, USA (California)

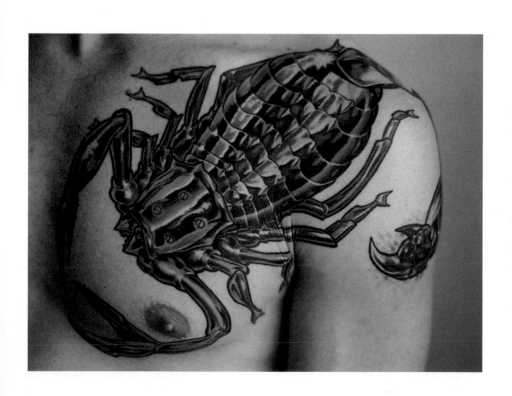

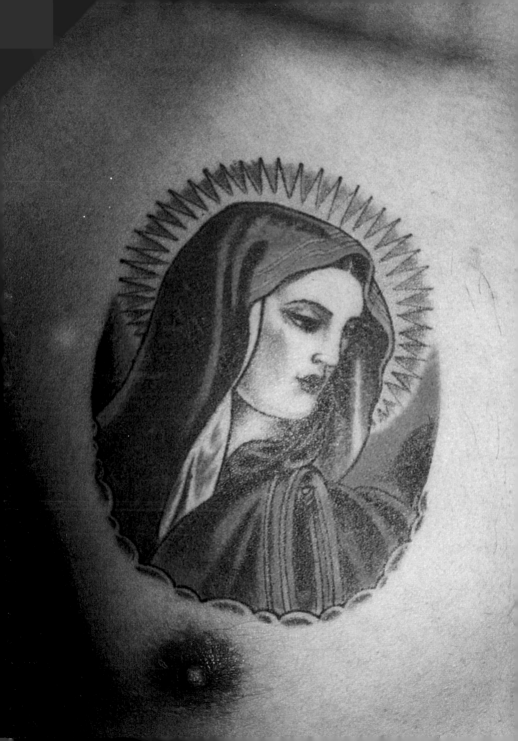

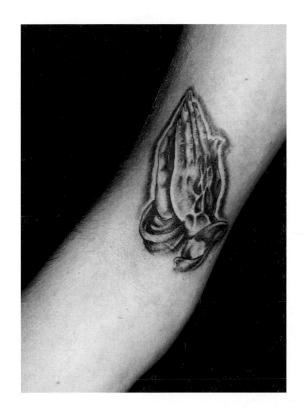

Fred Corbin, San Francisco, USA (California)

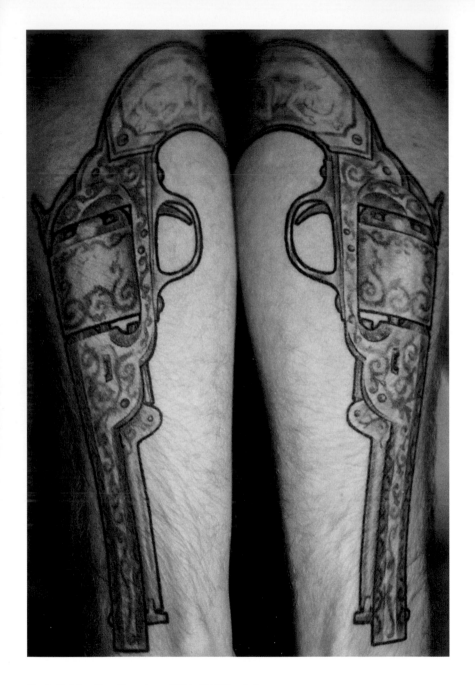

Scott Sylvia, San Francisco, USA (California)

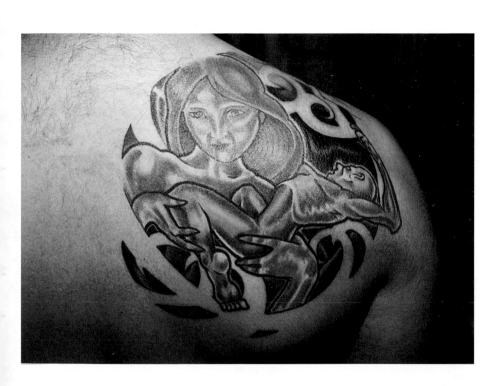

"Buy them all and add some pleasure to your life."

Art Now
Eds. Burkhard Riemschneider,
Uta Grosenick

Art. The 15ᵗʰ Century
Rose-Marie and Rainer Hagen

Art. The 16ᵗʰ Century
Rose-Marie and Rainer Hagen

Atget's Paris
Ed. Hans Christian Adam

Best of Bizarre
Ed. Eric Kroll

Karl Blossfeldt
Ed. Hans Christian Adam

Chairs
Charlotte & Peter Fiell

Classic Rock Covers
Michael Ochs

Description of Egypt
Ed. Gilles Néret

Design of the 20ᵗʰ Century
Charlotte & Peter Fiell

Dessous
Lingerie as Erotic Weapon
Gilles Néret

Encyclopaedia Anatomica
Museo La Specola Florence

Erotica 17ᵗʰ–18ᵗʰ Century
From Rembrandt to Fragonard
Gilles Néret

Erotica 19ᵗʰ Century
From Courbet to Gauguin
Gilles Néret

Erotica 20ᵗʰ Century, Vol. I
From Rodin to Picasso
Gilles Néret

Erotica 20ᵗʰ Century, Vol. II
From Dalí to Crumb
Gilles Néret

The Garden at Eichstätt
Basilius Besler

Indian Style
Ed. Angelika Taschen

Male Nudes
David Leddick

Man Ray
Ed. Manfred Heiting

Native Americans
Edward S. Curtis
Ed. Hans Christian Adam

Paris-Hollywood.
Serge Jacques
Ed. Gilles Néret

20ᵗʰ Century Photography
Museum Ludwig Cologne

Pin-Ups
Ed. Burkhard Riemschneider

Giovanni Battista Piranesi
Luigi Ficacci

Provence Style
Ed. Angelika Taschen

Redouté's Roses
Pierre-Joseph Redouté

Robots and Spaceships
Ed. Teruhisa Kitahara

Eric Stanton
Reunion in Ropes & Other
Stories
Ed. Burkhard Riemschneider

Eric Stanton
The Sexorcist & Other Stories
Ed. Burkhard Riemschneider

Tattoos
Ed. Henk Schiffmacher

Edward Weston
Ed. Manfred Heiting

www.taschen.com